THE
STUCKISTS
PUNK
VICTORIAN

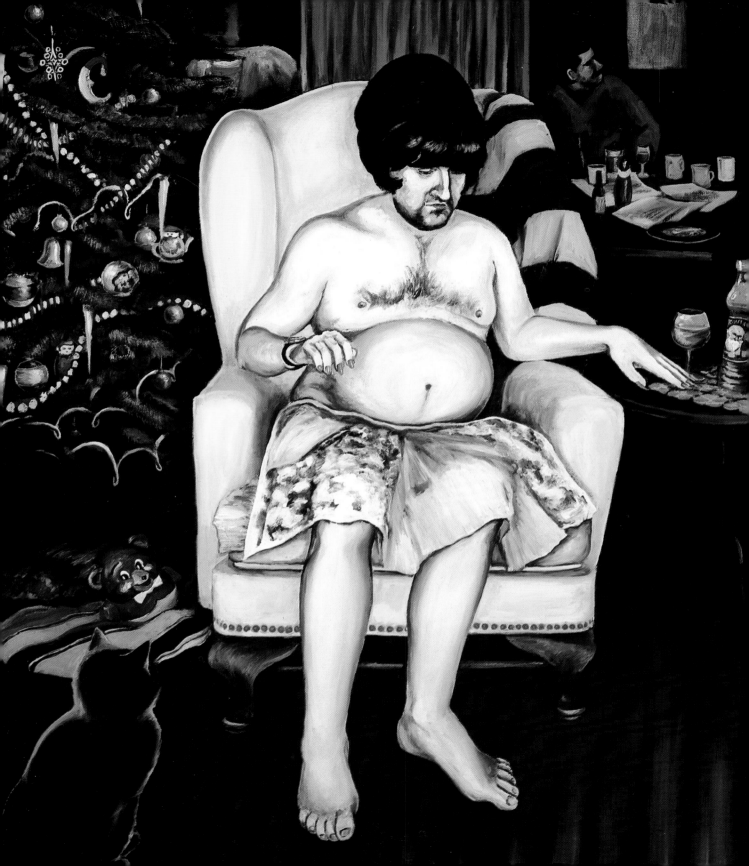

THE
STUCKISTS
PUNK
VICTORIAN

NATIONAL MUSEUMS **LIVERPOOL**

CONTENTS

© 2004 Board of Trustees of National Museums Liverpool

Edited by Frank Milner
Book design by March Design, Liverpool
Book production by The Bluecoat Press, Liverpool
Printed by Ashford Colour Press

This book was published to accompany the exhibition THE STUCKISTS PUNK VICTORIAN at the Walker, Liverpool
and Lady Lever Art Gallery, Port Sunlight, 18 September 2004 – 20 February 2005

ISBN 1-902700-27-9
British Library Catalogue in Publication Data available

A STUCKIST ON STUCKISM

THE BATTLE OF TRAFALGAR 4 JUNE 2001

I was rather surprised to see Sir Nicholas Serota, the Director of the Tate Gallery, appear in front of me in Trafalgar Square. He had made his way from the celebrity group through the common throng to seek me out. I thought at first he had come along for a friendly chat, till I noticed an expression taut with suppressed rage and heard him intone, "That was a cheap shot, using another artist's work to promote your ideas."

The artist in question was Rachel Whiteread, whose sculpture *Plinth* (a resin cast of an empty plinth inverted on the empty plinth, thus making two empty plinths) had just been unveiled by the then-Culture Minister, Chris Smith, before a renta-crowd of dignitaries. Smithy was my political rival, as I was standing against him in Islington South and Finsbury as a Stuckist candidate in the then current 2001 General Election. The moment he left the podium, I saw an unexpected opportunity, leapt over the metal crowd barrier (scraping my shin in the process), stepped onto the now-vacant platform and began addressing the crowd through the PA system about the shortcomings of conceptual art and the Turner Prize, which was delivering its yearly snub to Turner and all other painters by completely ignoring them.

I was holding a large placard which read 'MR SMITH, DO YOU REALLY THINK THIS STUPID PLINTH IS A WORK OF ART?' Simultaneously other Stuckist artists and supporters, strategically situated, held up placards with their own messages. Among this elite cadre were fiery poet S.P. Howarth (soon to be kicked out of Camberwell College), 'the Giggly Girls' (Susan Finlay and Katherine Gardner), an African Stuckist, a Basque Stuckist, Kat Evans and Stella Vine. One of the Royal Society of Arts organisers then summoned the presence of mind to turn off the power to the PA, and I returned to what I erroneously assumed was anonymity in the crowd.

"It's Dada," I retorted promptly in an attempt to placate the irate Tate man with a reference to the disruptive World War One artists, whose weak latter-day descendents in Britart he so tirelessly promotes. The suggestion that he had just witnessed an historic act in a recognised art tradition did nothing to placate him and he carried on his attack: "So that gives you the right to do whatever you want to do whenever you want to do it?"

It seemed fairly obvious he meant the opposite to this, and, remembering he had in the past talked enthusiastically about his desire to work closely with artists' needs (and indeed how art should be challenging and artists not afraid of causing offence), I thought I would try an appeal in this direction: "You and a few people like you control the art world and what goes on in it, and *as artists* this is the only way we can put our point of view across."

I'm not sure whether he understood he was checkmated, or whether he realised he was being video'd, but he gave a dismissive wave of the hand, as with a feudal lord to an irritating serf, and stalked back through the throng. Obviously we had mounted the wrong kind of challenge and not been afraid of causing the wrong kind of offence. Nevertheless the encounter was a fine piece of street theatre. "That was Sir Nicholas Serota, the Director of the Tate Gallery," I shouted. "Three cheers for Sir Nicholas." But no one did.

STUCKISM IN 20 SECONDS 1999-

Stuckism is a radical and controversial art group that was co-founded in 1999 by Charles Thomson and Billy Childish (who left in 2001) along with eleven other artists. The name was derived by Thomson from an insult to Childish from his ex-girlfriend, Brit artist Tracey Emin, who had told him that his art was 'Stuck'. Stuckists are pro-contemporary figurative painting with ideas and anti-conceptual art, mainly because of its lack of concepts. Stuckists have regularly demonstrated dressed as clowns against the Turner Prize. Several Stuckist Manifestos have been issued. One of them, *Remodernism*, inaugurates a renewal of spiritual values for art, culture and society to replace the emptiness of current Postmodernism. The web site www.stuckism.com has disseminated these ideas, and in five years Stuckism has grown to an international art movement with ninety groups round the world.

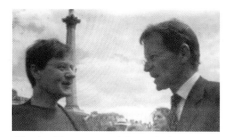

Charles Thomson and Sir Nicholas Serota in Trafalgar Square.

THE TWO STARTS OF STUCKISM

1999 VERSION

In January 1999 I was propped up in bed late at night in my suburban Finchley semi, which overlooked a stream and trees. During the previous three months I had assembled an embryonic art group, but had frustratingly failed to find an effective name for it. I started thinking about conversations with Billy Childish, with whom there had been a recent reconciliation after several years of little contact. On more than one occasion he had recited part of one of his poems to me, which recorded Tracey's invective that he was 'stuck' with his art, poetry and music. Apparently to make sure he didn't miss her drift, she reinforced it with: 'stuck! stuck! stuck!'

Impressionism was derived from the criticism 'impression' (i.e. that Claude Monet's work was not a properly finished painting) by Louis Leroy in 1874 in *Le Charivari* magazine. One hundred and twenty-five years later, I felt it would be best to be pre-emptive with this new insult: 'stuck-ism' would do nicely.

I buttonholed Billy in his Chatham kitchen a few days later as he was about to leave for a nearby poetry reading, and he agreed fairly casually to co-found this new art group *Stuckism*, once I had assured him I would do all the work, as his schedule was already full. There wasn't a problem with membership. That had been sorted out over the previous two decades.

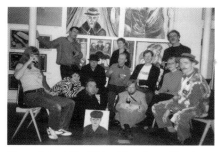

The original Stuckists: Standing; Charles Williams, Sheila Clark, Bill Lewis. Sitting; Frances Castle, Ella Guru, Joe Machine, Eamon Everall, Charles Thomson, Sanchia Lewis, Billy Childish. On the floor; Sexton Ming, Philip Absolon. Painting on the floor; Wolf Howard.

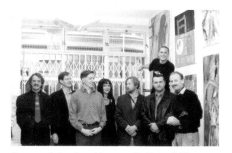

Some of the Stuckists at Gallery 108. Top: Joe Crompton, Director of Gallery 108. Standing: Bill Lewis, Charles Thomson, Billy Childish, Ella Guru, Philip Absolon, Joe Machine, Eamon Everall.

The Medway Poets (less Rob Earl) c.1979.
Miriam Carney, Bill Lewis, Sexton Ming,
Charles Thomson and Billy Childish.

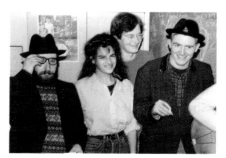

The Medway Poets LP recording,
December 1987. Sexton Ming, Tracey
Emin, Charles Thomson and Billy Childish.

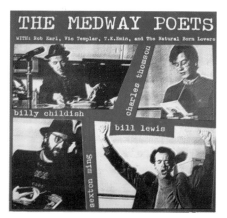

The Medway Poets LP, 1988.

The 1979 version was called The Medway Poets, whose core membership and associates subsequently formed the first Stuckist art group. It started in 1975 when Bill Lewis and his friend Rob Earl ran a series of poetry performances, *Outcrowd,* at the Lamb pub (later renamed Drake's Crab and Oyster House) by the River Medway in Maidstone, Kent. I was a student at Maidstone College of Art at the time and read at one of them. Billy read at a different one. These readings led into more of the same from 1979 onwards, promoted in The York pub backroom in Chatham by Alan Denman, a tutor at Medway Art College. That was where I first encountered Billy.

Driven on by Bill Lewis's fetish for all things Berlin Cabaret and the current punk explosion, in 1979 we formed an anarchic poetry performance group named by Bill *The Medway Poets.* As well as the later-to-be-founding-Stuckists Bill, Billy, Sexton Ming and myself were Rob Earl and Miriam Carney, my then girlfriend. Other subsequent founding Stuckists, Philip Absolon and Sanchia Lewis (Billy's girlfriend before Tracey), also contributed poetry.

Sheila Clark (whom Billy secretly married during his relationship with Tracey), Wolf Howard and Joe Machine were accrued over the next few years, although by then I was out of the loop, though not out of the area. I used to bump into Charles Williams in Safeway after he became a student at Maidstone Art College. His girlfriend was a friend of fellow student Tracey Emin – and eventually ended up, to her (innocent) chagrin, on a wall of the now incinerated tent. I met Eamon Everall when my first wife left me for him. Thus eleven out of the first thirteen-strong Stuckist group had been drawn into a small but complex network, where some people knew most people, but no one knew everybody.

The Stuckists put themselves forward now as artists, but there is, and always has been, work in all media – film, photography, performance, music, fiction, poetry and painting. In 1979 there was a series of one-man painting shows at Peter Waite's Rochester Pottery, though at that time it was poetry that was to the fore as a group identity.

The Medway Poets performed at pubs, colleges and festivals, notably the 1981 International Cambridge Poetry Festival. Bill Lewis jumped on a chair, threw his arms wide (at least once hitting his head on the ceiling) and pretended he was Jesus. Billy sprayed his poems over anyone too close to him and drank whisky excessively. Miriam told the world about her vagina. Rob and I did a joint performance posing, with little difficulty, as deranged, self-obsessed writers. Sexton finally

introduced us to his girlfriend, Mildred, who turned out to be a wig on a wadge of newspaper on the end of an iron pipe. She liked his poems.

In 1982 TVS broadcast a documentary on the group. The night it was filmed, Billy ended up in tears over a parting from Sanchia, but found consolation afterwards at a party in Gillingham, when he melded with a new woman 'Dolli' aka 'Traci' (later 'Tracey') Emin, an eighteen-year-old fashion student, in what turned out to be an intense obsessive relationship. I had a lot of sympathy for her (if you want to know what Billy was like in 1979, then look at what Tracey was like in 1999).

She called round occasionally to seek solace and show me her writing, which Bill later 'edited' into reasonable shape, I printed and Billy published as *Six Turkish Tales* (Hangman 1987). This was one of dozens of publications at the time. After only a couple of high-powered intense years, the poets drifted apart, with intermittent awkward reconvenings, such as the 1987 reading for *The Medway Poets* LP (now £46 on EBay).

In 1997 I bumped into Billy and his then-partner Kyra de Coninck at the back of the Leicester Square Warner cinema after watching *Wayne's World*, and over the following two years entered into an increasing dialogue with him. To my surprise, the intervening years had brought a convergence, especially through the overlap of our spiritual interests – his via Buddhism and mine from Kabbalah – including research into astrology and 'past lives', as well as an overlap in cinematic entertainment.

I also called into Tracey's Waterloo Road 'Museum'. I had only just re-entered art after a fifteen year sabbatical (so, coincidentally, had Bill Lewis) when I was a full-time poet and took no interest in the art world. I was rather taken aback that Tracey obviously now considered herself on a different level and something of an art celebrity. She didn't look much different to me, although she did look at me differently.

THE VIRTUAL STUCKISTS JANUARY – JULY 1999

Billy was on board and the group had (re)constituted itself fairly quickly and easily. It turned out that Billy had also already garnered an embryonic group with the name *Group Hangman*, and had even issued some manic manifestos, which were the starting point for the later Stuckist manifestos. *Hangman Communication 0001* (7.7.97) states, 'The conceptual artist arrives on the scene and frozen with fear, like some anal retard, is too scared to transmute their ideas into paint.'

Sexton Ming began proclaiming confidently he was 'stuck', and then asked, "My girlfriend Ella (Guru) does good paintings – can she join?" She in turn enlisted her friend Frances Castle. Ella provided the expertise to start the Stuckist web site, and I spent hours with her cooped up in the room she shared with Sexton off the Holloway Road. It was an exciting project and there was the sense that we could reach out to the world. However, for the first few months there were only thirty-two hits on the site, thirty of them from Ella updating the site (and the other two, we suspect, from Frances). The site kept chugging quietly along and it's now over 100,000 – and not all from Ella. Most of the Stuckist groups have made their initial contact through the site. Stuckism is the first significant art movement to spread via the Internet.

A DYSFUNCTIONAL DECADE OF SAATCHI ART THE 1990S

In the seventies, when I was at college (where my degree show included an installation, was dubbed Postmodern and I succeeded in being the only person to fail in ten years), it was assumed that you concentrated on doing good work and then got passed up the chain till you reached the level you deserved, whether Royal-College-of-Art-graduate-turned-Head-of-Art-Department-on-a-lucrative-salary or independent-go-it-alone-artist-existing-on-a-good-hourly-rate-as-a-part-time-tutor. Eventually, when your career had failed, you became a Royal Academician. There was a system and it worked on some rough approximation to merit.

A decade of Britart in the nineties changed all that. A new factor was introduced into a delicately balanced art eco-system, namely an advertising mogul, whose massive financial, media and personal presence raged through the art jungle like a firestorm and left the literally burnt remains we face today.

Previously galleries nurtured artists and showed their work every five years. Saatchi swept into an artist's studio, bought their entire oeuvre in fifteen minutes and then, if they were lucky, gave them that amount of Warholian fame. His superb promotional acumen shot a handful of artists to overnight (and sometimes durable) success, but his erratic spontaneous inclinations dropped a lot more quietly back into obscurity just as quickly.

It makes the art world randomly exciting, but does nothing to encourage any sustained development. What it has encouraged is a predominance of disposable, take-away, junk art, in a private emporium on the South Bank whose displays have the ersatz quality of a theme park. This kind of art is justified by the argument that it is a reflection of today's society. I find there is quite enough of today's society already, without adding to it.

It became possible because a startlingly innovative and original showman-cum-artist's aspirations synchronised perfectly with Saatchi's needs. Damien Hirst always wanted to be famous, and had the knack not only of finding a loud niche in the by-then febrile art world structure, but also of effortlessly acting the part of a Harry Enfield type character, the ridiculous yob artist, for the tabloids.

Saatchi is an ad man, who once ran the biggest agency in the world. He is a genius at advertising, but that is not much use without a product to advertise. Hirst was only too happy (then – he's not any more) to provide one. Saatchi switched from promoting Margaret Thatcher to promoting a dead shark, which some might think was not such a big change. He was certainly equally successful with both.

By the late nineties the predominance of the Hirst-led yBa's (young Brtish artists – a name devised by Saatchi) was undisputed. Those artists who had raised a voice of protest usually wore tweed jackets, sported beards, smoked pipes and had never even visited Hoxton, let alone lived in it, so they carried little credibility and were easily dismissed as 'reactionary' or 'traditionalists', the worst things you can be in brave new artspeak.

David Hockney became a celebrity in the sixties because he was recognised as the leading artist of his generation; he backed it up with a novelty line in glitzy gold jackets and distinctive glasses. Tracey Emin became a celebrity in the nineties because she got drunk and said "fuck" a lot of times on television; she backed it up with a novelty line in embroidered tents and unmade beds. That illustrates the change that had taken place in values.

The celebrity caucus of yBa's promoted by Saatchi effectively excluded all who were not part of it. Art students now saw their goal not as producing good art, but as producing art which they hoped Saatchi would

buy, and that art was known to be 'novelty art' for a self-confessed neophiliac. Tracey Emin is remarkable for gatecrashing her way into, and eventually upstaging, that elite circle, which proves that anyone could have done it if they were ambitious and/or desperate enough.

The main requirements are an art gimmick, shameless self-promotion, getting to know as many right people as possible, and, it would seem, finding some way of blotting out the hideousness of it all. Damien Hirst put it with his usual understated eloquence: "I started taking cocaine and drink ... I turned into a babbling fucking wreck." (*On the Way to Work*, Damien Hirst & Gordon Burn, Faber 2001)

There are many worthwhile artists who are constitutionally incapable of this route. They have too much integrity and are not prepared to pander to idiots. Their careers are doomed. I had known artists with doomed careers since the Medway Poets days. I felt particularly outraged that the reward for their integrity and dedication to their art, in lieu of dedication to going to the right parties (they do go to parties, but the wrong ones), was obscurity. I had no doubt their art had considerably more achievement, originality, intelligence and depth than the art that was being mass-marketed as the leading brand, sorry – art, of our times.

"A REVOLUTION WAITING TO HAPPEN" –
THE TIMES JULY – OCTOBER 1999

Anyone of reasonable intellect can only look at so many reproductions of a murky greenish pickled shark in colour supplements and magazines, before they start questioning why there are never any reproductions at all of Philip Absolon's witty, haunting paintings of jobless skeletons, Joe Machine's depiction of his gaunt, iconic bare-knuckle-boxer grandfather, Paul Harvey's exquisitely-wrought, affectionately lacerating recast of Tara Palmer-Tomkinson as one of Mucha's art nouveau vamps with a background of razor blades, Ella Guru's beehive wig-wearing demimonde pub musicians, transvestites and absinthe drinkers, or Bill Lewis's depiction of his quest for God through images of tumbling ladders, trickster white dogs and blindfolded, unattainable lovers. At the very least it would provide a bit more variety.

This anomalous situation was a spur for starting Stuckism, which aims is to replace Britart with Stuckism in this country and to change art worldwide. It's a dirty job, but someone's got to do it. We have everything on our side – a collection of ramshackle artists and a

Joe Crompton, Director of Gallery 108.

Joe Crompton, Billy Childish and Charles Thomson at Gallery 108.

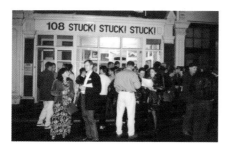

Private view of the first Stuckist Show, STUCK! STUCK! STUCK! September 1999.

Eamon Everall and Katherine Evans at the Real Turner Prize Show, 2000.

Ella Guru and Joe Crompton at the Real Turner Prize Show, 2000.

shoestring budget – against the spiritual and creative poverty of an entrenched self-replicating multi-million pound art establishment.

One thing is certain. It is no good relying on good art to win through by itself. If you want to get anybody to take any notice of the art, you have to get the attention of the media, which already had its art agenda dominated by the Saatchi/Serota axis. Most of the Stuckist artists have nothing to do with the PR side of things and wouldn't be in the group if they were expected to, though some such as Philip Absolon and ex-Para Daniel Pincham-Phipps (Southend Stuckists) stand there cheerfully and determinedly holding protest placards in all weathers every year outside the Tate.

In 1969, aged sixteen, I hired a council hall to run the Havering Arts Lab for performance art. When my second booking was cancelled by the council, I informed the local *Havering Express*, whose next headline promptly proclaimed in the biggest type face they could fit in: "SEX ORGY TALE – GROUP BANNED". So it was that easy to become front page news.

When the Medway Poets started, stories were fed to, and regularly appeared in, the regional and occasionally national press, culminating in the TVS documentary on the group. This level of media prestige greatly impressed the local aspiring art community, and became a model for others to emulate, Tracey Emin being the most, and rather excessively, successful in this regard.

Shortly after the foundation of the Stuckists in 1999, Tracey was nominated for the Turner Prize, and on 29 July Harry Phibbs of the *Evening Standard 'Londoner's Diary'* relished pointing out the connection. *The Sunday Times Culture* supplement followed in hot pursuit with the Stuckists featured on their cover, and a story inside that included such gems as Sexton Ming's transformation of Brit Art to 'Brit Shit'. Not long after, Dalya Alberge of *The Times* wrote a full-page article on a 'revolution waiting to happen', with three paintings in full colour, including Wolf Howard's *Dog and Cat Underwater*. "I bet you didn't think that would end up in *The Times*," I said to him. "No," he replied, "I thought it would end up in the skip."

Other papers and television programmes (including Jeremy Paxman's very serious *Newsnight* were fascinated by the novel spat taking place with the added potency of the ex-lovers' feud. Tracey was not best pleased. In fact she was privately very angry, felt she was being exploited, ordered Billy not to speak to the press and to tell me, helpfully, that I should be 'careful' who I spoke to as it could get 'distorted'. She reversed her normal policy of raging at those who

displeased her, and maintained an immaculate public silence, with closet irate calls to journalists.

The whole of Britart instinctively closed ranks. Artists such as Hirst, who normally bent over backwards for the media (on more than one occasion literally) were remarkably unavailable when asked to take place in debates with the Stuckists. Even prestigious programmes such as Radio 4's *Today* were left empty-handed and had to substitute Richard Cork, then art critic of *The Times*. *Newsnight* finally managed to obtain one artist in the Saatchi collection willing to appear for the defence of conceptual art, Brad Lochore, although, ironically, he was a painter.

GALLERY 108 AND JOE CROMPTON SEPTEMBER 1999 – OCTOBER 2000

Gallery 108 was named after its address, 108 Leonard Street in Hoxton. It is now occupied by the offices of Sally Hope, theatrical agent for the likes of Rowan Atkinson. In 1999, however, she was a behind-the-scenes partner with Joe Crompton, the unsung hero of Stuckism. Joe was fresh-faced, bright-eyed and not long out of college. In 1997 he had converted the initially-floorless ground floor into a small gallery which he dedicated to painting – in a district renowned as the breeding ground of conceptual art. He often stayed the night in a sleeping bag on the floor, which he had by then installed, and relied on food handouts from Home restaurant next door.

Frances Castle lived in a loft apartment just round the corner in Phipp Street, close by the site of The Theatre, where some of Shakespeare's most renowned plays, including *Hamlet*, were first performed before his company decamped to South of the river. Frances subsequently decamped also, because of spiralling rent in the area. Fortunately, before this happened, she wandered into the gallery and introduced herself to Joe.

STUCK! STUCK! STUCK!

Apparently he seemed fairly casual about everything and might well be willing to show the Stuckists. I didn't have any contacts in the London gallery world and pitched up clutching *The Sunday Times 'Culture'* supplement as my passport. Within five minutes we had a show booked for four weeks time. It was called *STUCK! STUCK! STUCK!* which was painted at the last minute in bold black letters above the gallery window. Preparation for it was frenzied, TV crews and journalists buzzed around and the private view spilled across the street, as proper private views should. Billy cheerfully responded in interviews, "I don't like a lot of the work." One TV report used background music from *Stealers Wheel*, whose lyrics went:

> *Clowns to the left of me*
> *Jokers to the right*
> *Here I am*
> *Stuck in the middle with you*

It even contained a line for Joe:

> *Is it cool to go to sleep on the floor?*

THE FIRST ART SHOW OF THE NEW MILLENNIUM

There was support from another venue also. *The First Art Show of the New Millennium* opened at 00.00 on 1.1.00 in the late Danielle Dodd's Salon des Art in Kensington, which also hosted several talks and in June that year there was a Students for Stuckism show, co-ordinated by Matthew Robinson with students from Camberwell, St Martin's, Chelsea, UCL and Falmouth.

THE RESIGNATION OF SIR NICHOLAS SEROTA

The next show at Gallery 108 was in March 2000, and titled *The Resignation of Sir Nicholas Serota*, though he signally failed to take the hint. Several artists painted work on the theme; Ella did a fetching watercolour of the Tate Director with a dead horse hanging upside down from the ceiling. I managed to finish *Sir Nicholas Serota Makes an Acquisitions Decision* just in time. It shows him standing behind a large pair of red knickers on a washing line, wondering if they are a genuine Emin artwork or not. Guest artists were shown for the first time, including the Students for Stuckism group from Camberwell College of Art. Two of them, Katherine Gardner and Susan Finlay, were inseparable and became known as 'The Giggly Girls' because they giggled so much. The show toured The Arts Club in Mayfair, the Red Dot Gallery in Ipswich and the Folkestone Metropole Arts Centre.

THE REAL TURNER PRIZE SHOW (2000)

Then Joe closed the gallery and became the Artistic Director of a new software company superHumanism.com. He persuaded them to turn their company launch into a Stuckist exhibition titled *The REAL Turner Prize* show, which took place in October 2000 at the other end of Leonard Street in what was then the Pure Gallery. Maeve Kennedy commented in *The Guardian* (24.10.2000):

> The Stuckists believe in getting their retaliation in first, and their bribes upfront: the invitations for their exhibition opening gave the lunch menu, running from champagne to bitter chocolate tarts, more prominence than the artists.

Although she scrupulously (and with some personal difficulty) refrained from the bribe of chocolate tarts, she did nevertheless in her report also succeed in giving them more prominence than the artists.

There was a crammed attendance throughout the evening at the private view, including a posse of professors from the Royal College of Art, an expensively-dressed lady delivered by limousine, and someone from my old Foundation course who thought that entitled him to walk out with bottles of wine. As an adjunct to the show, we staged our first anti-Turner Prize demo outside Tate Britain.

SIR NICHOLAS SEROTA KEEPS ON BUMPING INTO PEOPLE OCTOBER 2000

Superhumanism had agreed to fund a catalogue, which was compiled in a frenetic week for the printer's deadline, thanks to Kat Evans, a history of art student at University College London, who, unlike me at the time, owned a computer. Billy and I subsequently left a signed copy at the Tate for Sir Nicholas. It included my painting of him standing behind the red knickers.

Ranko Bon, a sort of 'postcard artist' (i.e. he sends out postcards with a text to his mailing list and has had displayed them in a gallery), had this story on one of his missives:

'The Giggly Girls', Katherine Gardner and Susan Finlay.

THE REAL TURNER PRIZE (October 24, 2000)
"Nick", I hugged Serota when I spotted him in the crowd at the Turner Prize opening at Tate Britain this evening, "it's wonderful to see you!" I was in one of my expansive moods, but I was genuinely glad to see him. He appeared pleased to see me, too. "Ah," I grabbed him by his bony shoulders, "when I look at you like this, I cannot but see Charles Thomson's portrait of you, which I saw last night at The Real Turner Prize Show in Shoreditch." I emphasized the word "real" with all my might. "Yes," Nick beamed back at me without even blinking, "I must see it!" Christ, I am so angry with Charles. I wanted to introduce him to Nick, but the scoundrel failed to show up at Millbank at six-fifteen this evening, as we agreed last night. I had even sent a message to the Tate to tell them that Lauren was in the States, and that I would come instead with a friend of mine, a co-founder of Stuckism."

Private view of Vote Stuckist show, Brixton 2001. S.P. Howarth, friend, Charles Thomson and Stella Vine.

But the hapless Chairman of the Turner Prize Jury was not going to get off that lightly. Five days after the opening where I'd stood up Ranko, Sir Nicholas Serota was enacting his own performance art piece called *Getting the Family Shopping in the Holloway Waitrose*, when he was accosted yet again, this time by a mischievous American called Ella Guru. Her journal takes up the tale:

"Excuse me ..." I said, very politely, of course, "you look terribly familiar ..."
At first the man looked at me as any non-famous person would if a stranger approached them with such a line. After all, Nicholas Serota is not really someone the general public would recognise.
"Is your name ..." I continued with his first name, and he finished with his surname. "I'm Ella," I said, "I'm a Stuckist." I really hadn't thought I'd say that. After all, we did have a show earlier this year called The Resignation of Sir Nicholas Serota.

Harold Werner Rubin, Director of the Rivington Gallery, Hoxton.

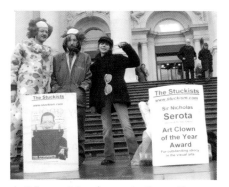

Anti-Turner Prize demonstration at Tate Britain, 8 December 2002. Charles Thomson, Philip Absolon and Gina Bold.

"Charles Thomson did a really good portrait of you." I continued.

"Oh yes," he smiled. "I'm on my way to see your show."

"We haven't been to see the new Turner Prize exhibition yet," I said. Nick and I were now walking towards the exit, pushing our shopping trolleys.

"There's some really good stuff in it," said Serota, "But there has been good work in the past years, too. I would say that, though." (Well not exactly that quote but something to that effect.)

We both laughed. He seemed very friendly really, especially considering Stuckism represents the opposition to everything he does.

He said again that he was going to see the Stuckist show soon. As we parted in the foyer, him prolly heading for the car park and me for my bike, he asked which pictures were mine.

"The ones with the big wigs," I said. He nodded and said he'd look out for them.

As far as we know he did not visit the show, and nor did the Turner Prize jury, which Simon Wilson, then Tate Curator of Interpretation, promised would come along in a Radio 4 *Today* programme debate with Joe Crompton.

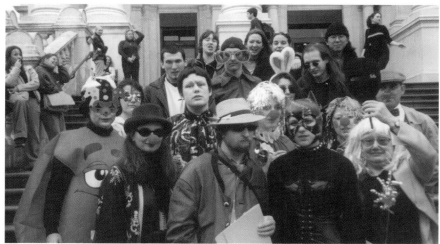

First anti-Turner Prize demonstration at Tate Britain, Nov 2000. Red M&M costume – Ella Guru; blue mask – Rachel Jordan; brown hat/red nose – Elsa Dax; brown shirt – Fanny, straw hat – Philip Absolon; silver tinsel – Katherine Gardner; bunny ears – Michelle England; Cat Woman – Charlotte Gavin; dark glasses – Remy Noe; blue tinsel – Susan Finlay; black mask – Margaret Walsh; flat cap – Matthew Robinson.

FIVE SHOWS AND TWO EX-STRIPPERS MAY – JUNE 2001

On 31 May 2001 we launched five shows simultaneously in South and North London – three in Brixton including the Fridge Gallery and two in Hoxton at Harold Werner Rubin's Rivington Gallery and its annexe. (Harold also hosted the Real Turner Prize Show 2001 and later gained some brief national celebrity after he received a gas bill for nearly six billion pounds.) They were all called *Vote Stuckist* and coincided with my standing for the General Election as a Stuckist candidate.

During the launch, which was at the Fridge Club, Stella Vine introduced herself to me. She had just started painting, and I included her work in the show. By mistake we ended up getting married in New York a couple of months later (and separating a couple of months after that). Ella Guru, who like Stella, is an ex-stripper, was convinced it was all a publicity stunt. Maybe she knew something I didn't

STUCKIST ARTISTS IN THE ARTS CLUB 1999 – 2001

The Arts Club in Dover Street was founded by Dickens, amongst others, in 1863, and termed 'a most agreeable society'. I was a member from 1998-2002 and was allowed by the then Club Secretary Ian Campbell to use the bar on Thursday evenings for monthly meetings of Stuckist artists and friends. The members were exemplary in their tolerance and friendliness towards some decidedly unorthodox-looking individuals, especially when Billy Childish pitched up one evening straight from a band tour looking like an old tramp.

The Stuckists dutifully followed the dress code of 'smart casual' with obligatory jacket, and the only crisis occurred when one of the young members (termed by themselves collectively the 'young fogeys') complained with a scowl that one of my guests was wearing trainers. However, it transpired the guest had been invited by another not quite so fogeyish young fogey and was not a Stuckist at all.

Remarkably *The Resignation of Sir Nicholas Serota* show was hung in the Club basement room after its debut at Gallery 108 (tactfully renamed *The Stuckists: New Paintings*, as Serota was an ex officio member, not that he ever went near the place). Billy and I also gave a talk on Stuckism and Remodernism which was well-attended and received by members and guests. There have been some genuine expressions of regret that the meetings eventually petered out, especially from Philip Absolon who does a good Augustus John look-alike act and found the Club a fitting environment to identify with his eccentric hero.

THE CLOWNS AT THE TATE 2000 – 2003

This is not a reference to the curators, but to the Stuckist anti-Turner Prize demonstrations, the first of which was on 28 November 2000. We turned up dressed as clowns, on the premise that the Tate had been turned into a circus. There was a lot of anticipation, crowd barriers across the steps of Tate Britain and a throng of orange-clad security guards, borrowed from Tate Modern. I was being video'd for a Channel 4 documentary on Charles Saatchi and had to travel from Finchley by tube in a ballooning bright yellow clown costume with a rainbow wig and red nose, which made me feel a little self-conscious *en route*.

As I turned into Milbank a guard spoke into his walky-talky, "Clown number one is arriving. Clown number one is arriving." I think this was because I was the first to arrive, rather than an estimate of my status. Meanwhile the Giggly Girls were arriving from Dulwich in their own clown costumes being filmed for an E4 documentary in a series of stars of the future. Ella looked magisterial in a padded red M & M costume; Matthew

Robinson managed a red nose under his cloth cap, but the undoubted media hit was Charlotte Gavin (a Student for Stuckism) in a Cat Woman costume flicking a whip.

The winner of the *Art Clown of the Year Award* for outstanding idiocy in the visual arts was announced as Charles Saatchi by Margaret Walsh, Damien Hirst's godmother. (It was won hands-down for the following three years by Sir Nicholas Serota.) Then the parade of clowns trooped into the Tate to see the Turner Prize Show for achievement in art, which was won by commercial fashion photographer Wolfgang Tillmans. *The Guardian*'s story on the winner was headlined 'Turner winner riles the Stuckists', which probably riled the Turner winner. The Tate refused to allow the BBC to interview me in the Turner show, on the grounds that I would criticise it, and this would upset Wolfgang. The reporter confidently began her report by reporting this.

We repeated the clown demonstrations the following two years, and varied it in 2003 by swapping red noses for blow up sex dolls referring to the Chapman brothers' sculpture of the same subject. As guests arrived for the prize ceremony, they were greeted by the announcement, "Turner Prize preview – see the original here and the copy inside." Jay Jopling walked past stony-faced. Jake Chapman took it in his stride. Tracey Emin acted as though she hadn't noticed we were there (she probably hadn't).

Finally the guests were safely seated inside for dinner and the Prize ceremony. Sir Nicholas Serota introduced the guest of honour, Sir Peter Blake. Tension was at its height. The live broadcast was about to reveal this year's winner. Blake began his short speech with a comment that he was surprised to be invited, as he had previously been invited to judge the *Not the Turner Prize* and to join the Stuckist demonstration outside. There were cheers. Probably from Sir Nicholas.

THE DEATH OF CONCEPTUAL ART

The demonstration in 2001 against Rachel Whiteread's *Plinth* has already been described. There was a different one on 25 July 2002, when the Stuckists in customary clown regalia carried a coffin marked 'The death of conceptual art' down Charlotte Road and deposited it outside the White Cube Gallery (which represents Emin and Hirst) in Hoxton Square. This is the official date for the demise of conceptual art, though I think we were wrong, as I don't see how something can be dead if it didn't have any life to begin with.

CHARLES SAATCHI AND THE OFT ATTACK

In March 2004 a dozen complaints were lodged with the OFT (Office of Fair Trading) by Stuckists and others such as Christopher Fiddes of the Movement for Classical Renewal, alleging Charles Saatchi's practices were a breach of the Competition Act. After a few weeks of intense deliberation and media features, the OFT replied, 'we do not have reasonable grounds to suspect that Charles Saatchi is in a dominant position in any relevant market,' which was just another cruel smack in the face for him.

STRING UP THE PERPETRATOR

A demonstration we didn't even do deserves to be recorded. It was carried out independently in Spring 2003 by someone called Piers Butler, who, it transpired months later, was also the founder of the Notting Hill Stuckists. Cornelia Parker had been allowed to create an 'artwork' in Tate Britain by wrapping Rodin's sculpture *The Kiss* in a mile of string. Piers turned up at the Tate with a sharp implement, cut the string and began removing it, on the reasonable premise that if Rodin had wanted it wrapped in a mile of string he would have done so himself in the first place.

I was puzzled that Parker had been allowed to do her string-wrapping – thereby using another artist's work to promote her ideas – as this was precisely the allegation that an enraged Serota had thrown at me in Trafalgar Square and dubbed a 'cheap shot'.

"I'VE WRITTEN A MANIFESTO" AUGUST 1999 – DECEMBER 2000

"How do I deal with this?" I thought to myself in August 1999, as Billy read to me over the phone a Stuckist manifesto he had just written with such gems as "the Stuckist must always endeavour to fail," "Stuckists ... are glorious in their courage to be loathed, hated and despised," and "personal expression should ... allow the artist to experience him/herself as crap."

It could provide a clue as to why he felt the artists weren't always in tune with his ideas. I asked him to explain what he meant by some of the phrases and very soon I had got sucked into co-writing a new manifesto, *The Stuckists,* based on it. I don't even like manifestos, but I recognised we needed some kind of public text. Billy was determined and provided the driving force for this and subsequent co-written effusions.

It is sadly simple to arouse an incandescent reaction in the current art climate of doctrinaire thinking, especially when opponents readily refer to statements we have never written in the first place and ask, for example, how we can possibly defend the statement that nobody should do anything apart from painting. As they've fantasised it into existence, it's up to them to find a suitable defence, I reckon.

Most people either never get as far as the end of the first manifesto or suffer from some form of temporary blindness when they do, as they seem oblivious of the clause that exempts us from everything (well, not quite everything):

> *Stuckism embraces all that it denounces. We only*
> *denounce that which stops at the starting point.*
> *Stuckism starts at the stopping point.*

The best known, most quoted and most contentious statement is:

> *Artists who don't paint aren't artists.*

This arouses criticism for being dogmatic, usually from the same people who would have no problem reiterating a dogma that suited them such as 'painting is dead'. Our statement seems to me quite clearly a happy logical contradiction. However, people are welcome to see it as dogmatic and get angry about it if it helps.

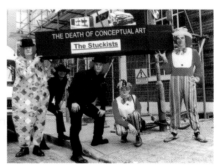

Death of Conceptual Art demonstration outside the White Cube Gallery, Hoxton Square, 25 July 2002. Charles Thomson, Gina Bold, Joe Crompton, Mary von Stockhausen and Alex Pollock.

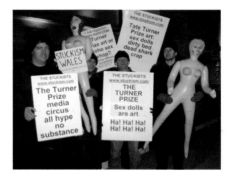

Anti-Turner Prize demonstration at Tate Britain, 7 December 2003. Steve Yates (film maker), John Bourne, Daniel Pincham-Phipps and Charles Thomson.

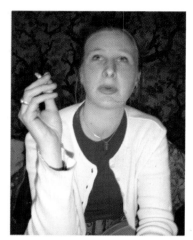

Mary von Stockhausen, Stuckism International Centre, Germany.

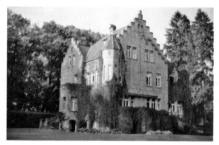

The Stuckism International Centre Germany.

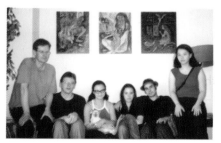

Terry Marks' flat in New York, August 2001. Charles Thomson, Nicholas Watson, Terry Marks, Marisa Shepherd, Jesse Richards and Catherine Chow.

Billy has studied Buddhism and practised it with Vipassana meditations, sitting still for ten hours a day. I have studied and taught Kabbalah (though not the Hollywood brand of it) for nearly thirty years. Both these spiritual disciplines have fed into the manifestos, which were always intended as catalysts and not a creed. Artists were attracted to Stuckism because they identified with the spirit of it. The manifestos are only one manifestation of Stuckism, but, because we are in a culture where it is generally easier to read words than pictures, they have assumed more importance than they should. The real manifestos are on canvas and written with brushes. Nevertheless, it has to be said that the manifestos are classics in the genre.

Billy was very keen on putting God into our second manifesto *Remodernism*, and this succeeded in rousing even more hostility than non-painting artists not being artists. God, we discovered, is customarily squashed in the recesses of the contemporary collective shadow, causes even more offence than tradition, and should not be freely thought about in a free-thinking society. No wonder art theorists stick to acceptable miasmas such as 'I'm an artist, so if I say something is art, then it's art', and don't risk their reputations by even getting as far as its logical corollary: 'I'm an artist, so if I say something isn't art, then it isn't art', let alone God.

STUCK ALL OVER THE WORLD 2000 –

In October 2000 an email arrived from Regan Tamanui, who then started the Melbourne Stuckists. He staged a *Real Turner Prize Show* concurrent with ours in what he called his backyard, which I assume is Australian for art gallery, and then had the same debate on Australian TV that we were having on British TV.

Connie Lösch, a journalist for *Junge Welt*, curated five Stuckist shows in Germany, including a concurrent Real Turner Prize Show 2000. A month later Mary von Stockhausen formed the Lewenhagener Stuckists in Germany, has a room in her castle dedicated as a Stuckist gallery and is building an outdoor sculpture park in the form of a maze.

We decided to 'franchise' Stuckism, so that interested artists, of which there were a growing number, could form their own independent, self-directed groups, named after their location. It was based on the model of linked but separately run sites on the web. In 1999 there was one group, in 2000 there were four, the next year thirty-five and now there are ninety in twenty-two countries (Australia, Belgium, Brazil, Canada, Chile, China, England, France, Germany,

Greece, Ivory Coast, Ireland, Israel, Italy, Japan, Jersey, Poland, Scotland, Spain, Sweden, USA and Wales).

Jeffrey Scott Holland of the mid Kentucky Stuckists organised a travelling show of Stuckist paintings in America in 2001 from Richmond, through Los Angeles, Seattle, Orlando and eventually New Haven. Elsa Dax curated a Stuckist show in Paris the same year. Jesse Richards and co. in New Haven (two hours' drive from New York) opened a gallery in 2002 and staged demonstrations including the 2003 anti-war *Clown Trial of President Bush* on the steps of the New Haven Federal Courthouse.

Billy Childish, Co-founder of Stuckism (left the group 2001).

STUCK IN THE UK

In this country independent groups have also been active. Paul Harvey, of the Newcastle Stuckists, curated a show in the Newcastle Arts Centre in 2002 and another with the Japanese Ryu Art Group in Northumberland in 2004. Dan Belton in Brighton relentlessly puts on Stuckist exhibitions in Worthing library. John Bourne nominated his home a Stuckist Centre for Wales. The Maidstone Stuckists, founded by Remy Noe, go on group outings for life and landscape painting and getting drunk, as well as staging shows in the Kent Music School, fairs, art shows, and their favourite venue, pubs. Raj Patel, not a Stuckist but Head of Museums in Sandwell near Birmingham, deserves a special mention for promoting the first Stuckist show in a public gallery at Wednesbury Museum in 2003.

EX-STUCKISTS

There are also 'ex Stuckists'. The most significant in their interaction with Stuckism are Billy Childish, Tracey Emin, Stella Vine and Gina Bold.

BILLY CHILDISH LEAVES THE STUCKISTS

Billy's parting from the group in June 2001 was amicable, sensible and unavoidable. He continues to liaise frequently on a personal basis with Stuckist friends. Wolf Howard is the drummer in the same band as Billy – *The Buff Medways*. Here are notes compiled from a recent phone conversation with him.

"Before 1999, Tracey Emin and Sarah Lucas offered to get me exhibitions, but joining the Stuckists put a kaibosh on all that – because I wasn't prepared to be controlled. I agreed to co-found the Stuckists to be allowed to say what I wanted, and I left the Stuckists because I didn't really want to be in them in the first place. Tracey still says I'm in the Stuckists, as a weapon, even though she knows full well that I'm not.

"Stuck! Stuck! Stuck" was actually written about 1991 or 2 in a poem about how I wouldn't go to a party. Tracey was basically having a hissy fit because I wouldn't bow down to her demand that I endorse her new kind of art, which I told her was old hat, so she attacked mine. Seven years later Charlie fancied it as a name for a group.

I'm far too interested in doing paintings, not organising shows, so if someone else wants to organise things on a group level, then fine – it gets more momentum. I thought the opinions might be heard more. My problem was being a member of a group. I'm very independent. I'm a leader of one person. I'm very arrogant and petulant in situations where anyone has any control over me.

I thought 'my God, what am I in?' at the first show. I was asked to stay on by Charles. Charles is the founder of Stuckism. I'm the excuse. That's how I feel. I didn't like a significant amount of the work. I found that I'd be exhibiting with a catalogue or poster which I thought typified Britart and not my views.

The manifestos were the only thing that made sense to me in the Stuckists. I believe in the ideals stated within the manifestos but I don't think many of the other Stuckists were bothered or interested in them. The Remodernist manifesto was received in a very hostile way. Even my friends within the group were obviously not motivated by the same things that I was. I didn't get on with Joe Crompton, and doing a press thing outside, holding our paintings above our heads – too *Beadle's About* for me. "All publicity is bad publicity" (*Hangman* manifesto).

I thought I'd done what I needed to do. The group had done what it needed to do. And for me that was writing the manifestos – understanding what was happening and having the guts to tell people. It was all about having a voice to expose what a bunch of charlatans they all are, although I knew full well we wouldn't be given credit for doing it.

I think Stuckism has been very successful. People like Matthew Collings, who would never criticise the edifice of contemporary art, now criticise in the same way, but three or four years later. I predicted that right from the beginning."

TRACEY EMIN

Tracey Emin was never in the Stuckists, so can't by strict definition be an ex-Stuckist, but the Stuckists grew directly out of The Medway Poets, and Tracey was certainly a graduate of that school (mainly, but not exclusively, from her association with Billy Childish) and not of Goldsmith's College, which, unlike the other yBa's, she never attended although it is often assumed that she did. It is this early artistically-formative time of her life that makes her art with its emotional confessionalism so different to the clinical detachment of other Brit artists. But don't take my word for it. Let Tracey speak for herself in the *Minky Manky* catalogue (1995).

> *Carl Friedman: Which person do you think has had the greatest influence on your life?*
> *Tracey Emin: Uhmm … It's not a person really. It was more a time, going to Maidstone College*
> *of Art, hanging around with Billy Childish, living by the River Medway.*

So there you go. It's not a person. It's Billy Childish. 'Hanging around' is a bit of an understatement. Curiously this quote was not mentioned in the 2002 Thames and Hudson book *The Art of Tracey Emin* (edited by Mandy Merck and Chris Townsend) which trumpets 'distinguished critics' apparently 'tracing her influences.' Rather sloppy to have missed out the greatest one. Scholarship is obviously not what it used to be.

STELLA VINE

Stella Vine had started painting in part-time classes at the private Hampstead School of Art, shortly before her work received its first public exhibition in the *Vote Stuckist* show in Brixton in June 2001. She took part in the Stuckist protest in Trafalgar Square against Rachel Whiteread's *Plinth* and founded the Westminster Stuckists. She also bought two Billy Childish paintings, one by S.P. Howarth and one by Joe Machine.

Stella Vine exhibits her work in the Vote Stuckist show, Brixton, June 2001.

She rejected the group after five months and now expresses extreme hostility to the Stuckists. She denies there has been any influence by the Stuckists on her work. However, motifs, subjects and ideas which were in Stuckist paintings in the *Vote Stuckist* show or which she saw elsewhere at the time – and which were not then present in her work – have appeared subsequently, such as blood dripping from the mouth (Joe Machine's *Until the Last Dog is Hung*), and the depiction of a public personality with their imagined private thoughts written on the canvas (*Sir Nicholas Serota Makes an Acquisitions Decision*). Both of these elements are present in her now (in)famous picture of Princess Diana, *Hi Paul Can You Come Over* bought by Charles Saatchi.

Saatchi's successful worldwide promotion of Stella and her painting as his 'discovery' without any reference to her previous Stuckist involvement threatened to hijack important elements of our identity as his own innovation in art. This was particularly threatening as he has also restated other ideas which we previously promoted, such as the need for art to exist outside the mandatory 'white wall gallery' – iterated in 1999 in our manifesto and reiterated by him in *Time Out* in 2003. The press has subsequently drawn attention to Stella's Stuckist connection, and this is now generally accepted as an important part of her story, though not by her.

GINA BOLD

Gina Bold did her first painting at Stuckism International in June 2002. She was exhibited for the first time as a Student for Stuckism in *The First Stuckist International 2002*, and in subsequent shows, including Wednesbury Museum, as a guest artist. She took part in the White Cube and Anti-Turner Prize demos in 2002. There was a big bust-up at the end of 2003 which resulted in the cancellation of the *Real Turner Prize Show 2003* and her rejecting the Stuckists. She now describes herself as 'an independent London artist', and is currently painting prolifically.

Gina Bold and Charles Thomson painting at Stuckism International, London, December 2002.

Sexton Ming and Ella Guru's marriage in drag in Dorset, 21 April 2001.

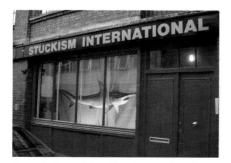

The window of Stuckism International London, 17 April 2003 – the opening day for the Saatchi Gallery.

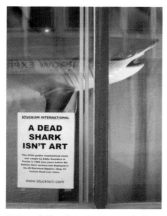

A Dead Shark Isn't Art – window display, Stuckism International.

HAPPY STUCKIST COUPLES

Sexton Ming and Ella Guru were together before Stuckism, but married during it in 2001 (in drag on a Dorset cliff top). Charlotte Gavin – actually an (amicable) ex-Stuckist and cat woman in the first Tate demo – met Joe Machine at The Real Turner Prize Show in 2000; they married two years later. Rachel Jordan left London in 2001 to embed herself in Chatham with Wolf Howard.

STUCKISM INTERNATIONAL APRIL 2002 – SEPT 2004

In 2002 I moved to a converted Victorian warehouse in the art heartland of Shoreditch, seventy yards from Jay Jopling's *White Cube* gallery in one direction and not much further to the Prince of Wales' *The Prince's Foundation* in the other. Some people call their homes *Rose Cottage*. I called mine *Stuckism International*, and hung paintings in my living room, which is, according to the Stuckist manifesto, where they should be viewed 'with access to sofas, tables, chairs and cups of tea'. This unique collection of Stuckist paintings became quite popular. The most unexpected visit (or rather non-visit) was on 15 May 2004.

I learnt about it when my neighbour (who designs packaging for the Tate) bounced in excitedly, and reported that a black cab had earlier pulled up outside his front door, disgorging Charles Saatchi and domesticated goddess, wife Nigella Lawson ('even more gorgeous than she looks on TV'). They had made a beeline for my window and stood there reading some posters I had put up, most of which were about Charles Saatchi – particularly one declaring 'STUCKIST ART IN 2001 IS SAATCHI ART IN 2004' referring to his recent 'discovery' of Stella Vine.

There was also a cutting from the *Independent on Sunday*, which stated that Stella was 'a protégée of the Stuckist movement' and that Sarah Kent, art editor of *Time Out* who moonlights as a book editor for Charles Saatchi, might have to revise her scathing opinion of the Stuckists 'now that Saatchi is following their every move'. Having just proved the statement true, the inquisitive couple then returned to their black cab, with its engine still running, and drove off, obviously not realising that not all doors open automatically for them and you have to ring the bell to get in.

WHAT'S THE BIG IDEA?

THE CONDENSED ONE THOUSAND YEARS OF ART

Medieval art was theocentric. The Renaissance was materialistic. Remodernism is holistic.

THE POCKET ONE THOUSAND YEARS OF ART

Medieval art placed God at the centre and portrayed the biblical vision of another world. The flat forms and decorative gold of icons reflect this non-material reality. From the Thirteen-hundreds and Giotto onwards there is an increasing three-dimensionality, as perspective, modelling and perceptual proportion (as opposed to Medieval conceptual proportion) evolve to maturity.

Thomas Aquinas discussed whether several angels can be in the same place at the same time (not necessarily as ridiculous as it seems, since quantum physics has its own variant on this, and Aquinas only ever apocryphally mentioned angels dancing on a pin), whereas Leonardo da Vinci sliced opened illicit cadavers to reveal the topography of a cold heart.

The priority switched from the inner to the outer, until the 18th century Enlightenment and subsequent scientific materialism reduced the inner to measurable interactions of neurons in a squidgy brain. Then scientific materialism was pushed to an extreme where it undermined itself and the clockwork of Newtonian mechanics was revealed on a deeper level to be underpinned by Einsteinian phenomena as strange Aquinas's. We have been through the whole panoply and the resolution of the dichotomy is neither heaven nor earth but a union of the two, which has been a cornerstone of Kabbalistic teaching for centuries.

THE LAST ONE HUNDRED YEARS OF ART

The two building blocks of two-dimensional visual representation are drawing and colour. The third element is the consciousness or vision that informs them. Before there is art, there is the human being who creates it. The outcome of the art is entirely dependent on what the artist brings to bear on it, this in turn being strongly modified by the surrounding culture. To have a profound and meaningful art, there must be a consciousness of profundity and meaning to generate it. Then the appropriate means must be available for the expression of this.

The Medieval period provided means for a partial expression of wholeness – the spiritual element. The Renaissance developed means for

a different partiality – the material. The story of Modernism is a panic to find something as substantial as either of them, when neither of them makes sense any more. But a new durable art only comes about from an equivalent philosophical depth, and that clarity was not there.

It was certainly necessary for Modernism to free drawing and colour from the strictly observational, which is an assertion of the material as the real and the subordination, or even denial, of the inner world of thought, feeling and imagination which is the greater part of our experience.

The Pre-Raphaelite Dante Gabriel Rossetti moved away from systematic single-point perspective, though his early ineptitude may have been just as contributory to this as his desire to bypass the High Renaissance. The Impressionists did not move from the drawing of externally observed form, but the career of Claude Monet took him from exquisitely observed light (pre-Impressionism) to a vision of the soul in his later work, where observation becomes a catalyst not an aim.

The Impressionists did, however, give Van Gogh the stepping-stone he needed to depict the synthesis of inner state relating to outer environment. His spiritual commitment to God and humanity, his personal striving and the impact of nature all fused with an equivalent innovatory technical vehicle in a holistic art. That his own life finally fell short is a different enquiry. A new art was created where form was the conduit of honesty, depth and intensity of consciousness. But thereafter no one artist could match this stature.

Modernism became a story of fragmentation. Each supposed innovation and movement, far from being a story of progress as it is often depicted, was part of a static uncompleted whole, rather as if each tradesman on a building site considered himself to be the entire workforce necessary to construct a house. The plumber comes along and puts in the boiler and pipes. The electrician turns up, tears out the central heating system and substitutes cables and light bulbs. Then the chippy does the same in turn, and the bricky, and the plasterer. At first they all believe in the value of their individual work as the only thing that matters, but eventually word spreads about what is really happening, until finally they are all disillusioned and just going through the motions to earn some dosh. That's the state of art today.

The key to understanding Modernism is of brave, but misguided enterprise. Each movement arrived at a truth, and thought it was the whole truth. Kandinsky introduced the spiritual in art with an appropriate form of abstraction, but negated the importance of material experience. The ultimate result of this divorce from the mundane is madness, as can be evidenced by those poor souls talking to God in mental wards and being spoon-fed tomato soup. Mondrian unearthed the geometrical skeleton which had always been there in art, but previously concealed, for very good reasons, by the flesh of image.

The Surrealists advocated the irrational, the dream and the unconscious, all again vital infusions into great art, but only of value when their meaningful relationship with daily life is revealed. Otherwise the endless irrationalities have no more import than neurotically toying with a Rubik's Cube. Jackson Pollock isolated the physical making process, and strove to contain his insecure alcoholism in repetitive patterns. The spontaneity of sensitive feeling was absent, but is confused in appraisals of his work with the urgency of muscular dynamism. By the time of minimalism and conceptualism the enervation of the heart is complete: a dry detached academia has squeezed all the blood out.

Charles Williams's painting table.

The two giants of the 20th century stand out because they come closest to the whole vision, but fall short in equal but opposite ways, Picasso because he could only see the ugliness, and Matisse because his art was only beautiful. Picasso's dazzling genius at plastic manipulation blinds an easy observation of his true status. In psychological terms he failed to evolve. He stayed at an infantile, egocentric emotional level and merely invented, with each new period, a different way of saying the same thing – which generally was a very limited thing to say in the first place. Can you trust his art? Well, would you trust him? I wouldn't, but I'm still fascinated by his prowess. Matisse gives us a pleasant holiday from life and that in itself is welcome, although eventually one pushes against the gilded bars.

Charles Thomson's painting table.

Warhol was the bridge between Modernism – the genuine belief in the new – and Postmodernism – the cynical view of moral and artistic relativity, and the retreat into irony, novelty, cynicism and commercialism. Warhol's life, as a churchgoer and soup kitchen helper, was greater than his art.

One legacy of Modernism is the creation of viable languages. Postmodernism's response to this is to play their forms off against each other in a superficial exercise, often to demonstrate the negation of any intrinsic worth in them. Impressionism has been 'done'. Expressionism has been 'done', likewise Cubism, pop art et al. That is the same as someone in Elizabethan England saying that the English language had been 'done' by Chaucer. The creation of a language is its beginning, not its fulfilment: that only comes about through the deeper and more extensive use of it through time and collective evolvement. Remodernism recognises that the one achievement of the previous hundred years is the bequeathal of these means, and that their development and deeper employment is a legitimate task for us now.

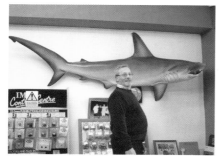

Eddie Saunders with the shark he caught (borrowed by Stuckism International) – on display in his JD Electrical shop since 1989, two years before Damien Hirst's version.

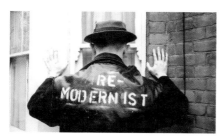

Billy Childish with 'Re-modernist' jacket.

THE MEDIUM MODIFIES THE MESSAGE

Artworks are now predominately defined, distinguished and given accolades in terms of the material they are made of. This is an incredibly limited approach to art, particularly when the medium itself is so incredibly limited. There is not much subtlety and flexibility possible if you are using a dead shark as the expressive material. In fact you can really only use it once, because beyond the fact that it has been used at all, there is little else it has to say.

The equivalent in verbal language to this level of achievement would be the vocabulary of a very young child, able to say that he or she hurts, but barely being able to say whether the hurt is in the stomach or the ear, and certainly not able to relay whether it is a sharp continual pain or a dull intermittent one. That necessary communication is only available with a more extensive and sophisticated dictionary.

Materials in art are a means to an end, not the end in themselves. The end is to address life, and to condense it to a symbolic form that enables us to relive and/or broaden experience and understanding through a 'magical' process.

Stuckists use paint as a medium, not because it is traditional, but because its flexibility has a potentially Shakespearian breadth, depth and subtlety. This medium takes second place to the subject; the material is not the cause celebre – the subjects depicted and the consciousness embodied are the primary concern. Even when paint asserts itself as a medium, to be experienced sensually in its own right, it still translates the artist's hand and mind unavoidably.

To see the materials used as the purpose of using the materials, does communicate, but what it communicates is the vacuity of that process and the lack of depth that informs it. This is why the general public are instinctively averse to such art. They may articulate their aversion in philistine clichés which makes it easy to dismiss them, but the origin of their aversion is a deeper sense that recognises that what is being promised is not what is being delivered, and that will not change even if Sir Nicholas Serota delivers Dimbleby Lectures till the pickled cows jump out of their vitrines and jump over the moon.

The diversification of 'artists' into other media, such as video, installation and performance, is equally futile. It is not that those media are not valid – quite the opposite. The futility is because they have been validated and brought to summation by the skills of others, who leave the so-called artists in the shade, snatching whatever scraps are left over from the main meal. Most video art is either an endless repetition

of something that would normally form a brief sequence in a major film, or else something which would have ended up on a major film cutting room floor because it was so boring in the first place. Performance art is better known as theatre, which is what its best practitioners call it. Installation and site-specific art is carried out with consummate achievement by architects and environmental designers worldwide, and, even though their ideas can often be dehumanisingly barren, the Fine Art version of this form doesn't do any better on that score. Text Art, just for the record, is known by people who do it well as literature, and, if it's written in short lines, it's called poetry.

A BEGINNER'S GUIDE TO STUCKIST ART
"We all choose to be painters, but not as if rock 'n' roll, television, cars, cinema, jazz, and the whole 20th century never happened. We're saying, 'Let's use paint to describe our lives now'" – Terry Marks, New York Stuckist

Stuckists and their art have been called many things in the press and by observers. A quick trawl reveals that we are neo-conservative, revolutionary, reactionary, progressive, traditional, anti-establishment, old-fashioned, new, obvious, controversial, clichéd, original, a backlash, radical, pop, expressionist, outsider, conceptual, anti-conceptual, craftsmen, daubers, trained, crude, precise, unfinished, thought-provoking, gauche, witty, naïve, deep, a joke, serious, contrived, authentic, insensitive, heartfelt, puerile, high-flown, clumsy, genuine, grotesque, important, bad and great.

These things may well be in Stuckism, but none of them is Stuckism. The contradictions that result from attempting to impose conventional definitions are inevitable, because the nature of Stuckism is to contain these opposites and integrate them. There's a very useful word which can be accurately applied to the nature of Stuckism, but it hasn't quite sunk in yet (although it is being 'tracked' by the OED so hopefully people will believe it sooner or later). It is 'Stuckist'.

It needs a new word for a new paradigm, just as, for example, Surrealism could not be meaningfully defined in terms of previous movements such as Classicism or Cubism: it had an entirely different segment of concerns, and interestingly, like Stuckism, it used a whole range of previous styles for a new purpose. Bill Lewis, one of the founder Stuckists, comments:

> *19th century and early 20th century intellectual thought emerged from the Newtonian/Cartesian Paradigm, whereas we are part of the emerging New Paradigm. Descartes' view of intellect was one of parts [compartmentalised] mentality. The New Paradigm, however, is holistic and about inter-connectedness rather than compartmentalism. We think with our whole*

*person. The mind is free from the bone prison of the skull. We are intellectuals of the heart.
Just as modernist thought was influenced by Einstein's Theory of Relativity (as can be seen by
Picasso's paintings for instance) the New Paradigm that Re-modernism identifies itself with is one
made possible by the discovery of quantum mechanics.*

Eamon Everall, another of the founding Stuckists, states Stuckist practice:

*The signal difference between Stuckism and former movements, many of which individual
Stuckists are undoubtedly influenced by, is that, unlike them, Stuckist artists are not bound
by a single easily identifiable stylistic 'look'. Visiting a show of Stuckist work the viewer will
be first struck by the diversity and eclecticism of the works on show, and it is this which
makes Stuckism so difficult for the critic. They find here no easy stylistic or technical hooks
upon which they can hang their outmoded critical methods.
The Stuckists as a group are not wedded to some formulaic and often stultifying notion of
what a painting should look like, as in past movements. For them the unifying element is
not visual: it is their overriding and enduring search for emotional veracity and their
concern with the authenticity and honesty of the creative impetus.
Stuckists paint primarily because they are driven to paint, driven to express that element of
their humanity which sets us apart from the animal world, namely creativity. Their work
does not seek to be clever or original for its own sake, and at times may even appear
clumsy and raw, but it is never dishonest and it never seeks to mislead or confuse the
viewer in the form of convoluted egoistic one-up-man-ship which we see so often in
galleries elsewhere today.
After a century of growing public alienation from the art world, Stuckism seeks to return the
enjoyment and involvement of art to where it belongs, to the maker and the viewer.
Stuckism, warts and all, is honest. What you see is what you get.*

The unification of Stuckist art is through the values that drive it, namely truth to self and experience in its
content, and clarity and directness in its expression and communication.

In 2003 documentary filmmaker Morgan Spurlock tried to live on a McDonalds fast food diet and
was soon experiencing headaches, vomiting, chest paints, listlessness, high cholesterol and toxic liver. These
are not known to occur with a whole food diet, but that doesn't provide such a cheap quick sensation of
seeming to fulfil a need. The fast food on the high street is mirrored by the fast art in the gallery. The effect
on the physique has its equivalent in the psyche. You're welcome to them if you really want them.

Stuckist art can be novel, but it is not made for novelty appeal. It gives a deepening rapport over
time that I fail to find with a fish carcass floating in a glass coffin. Its directness results from a meaningful
and balanced insight into complexity, and an unflinching acceptance of our humanity. Like all true art it
brings us closer to who we really are, and I have to confess I do eat McDonalds from time to time (I blame
it on my son).

Charles Thomson August 2004

No one radical will ever win The Turner Prize

Anti-Turner Prize demonstration at Tate Britain,
9 December 2001, with Tracey Emin cardboard cutout

MANIFESTOS FROM THE EDGE AND BEYOND

'That's the edge. That's the end.'
(*Rebel Without a Cause* 1955)

1

At the beginning of the twentieth century, orthodox British painting and sculpture was represented – as it had been represented for the previous hundred and fifty years – by the Royal Academy of Arts. If the general public thought about art at all then it was as the contents of each successive year's Summer Exhibition at Burlington House that they thought of it. The Royal Academy was 'the public conception of What Art Should Be In England.'[1] When unorthodox art of any kind came within the public's ken – usually with an '-ist' or '-ism' attached – it was treated as a joke. Hilarity greeted the 1910 Post-Impressionism exhibition at the Grafton Galleries where all was 'titter and cackle'[2] during a highly successful two-month run. Not that the painters most comprehensively represented in the exhibition – Cezanne, Gauguin, Van Gogh – could have been described at that time as in the forefront of the modern movement: Cezanne had been dead for four years, Gauguin for seven, Van Gogh for two decades. However, re-branded by Roger Fry as Post-Impressionists, they were startlingly new to the insular English public, who came in their droves to be shocked and amused: by Cezanne's portrait of his wife, by Gauguin's 'hideous brown women, with purple hair and vitriolic faces'[3], and by 'the visualised ravings'[4] of 'the unhappy madman Van Gogh.'[5] The public attending the exhibition were 'like dogs to music', one correspondent remarked, 'it makes them howl, but they can't keep away.'[6] Alongside those works from an earlier generation were paintings by men known in Paris as 'Fauvists': Derain, Vlaminck and, attracting particular attention from the sensation-seeking hordes, Henri Matisse, whose statement, that he aspired to see and paint as a child sees and paints, can be credited with originating the most enduring philistine cliché of the twentieth century. Although the exhibition also included some early works by Picasso, the English public would have to wait another two years[7] to be outraged by Cubism. These continental, Paris-based painters represented the world in strident colours and distorted forms, but they could not put anything over on straightforward, down-to-earth John Bull who was no-one's fool and liked to see a tree that looked like a tree and a sky that looked like a sky, and whose six-year-old, besides, could paint as well or better.

In March 1912, Signor Marinetti and his Italian Futurist Movement brought more funny foreigners with their funny foreign paintings to London for the public's entertainment[8]. Innovative art has always been a source of amusement to the English.

Such art is, by its very nature, anti-establishment, because it challenges that which is currently conceived of as 'What Art Should Be'. It was natural that the founders of the first abstract English art movement, Vorticism, the professed aim of which was 'to destroy politeness, standardisation and academic, that is civilized, vision'[9], should call their Great Ormond Street headquarters, the Rebel Art Centre. But its leader, Wyndham Lewis, and the rest of his Vorticist colleagues, were not only in revolt against art-establishment values as represented by the Royal Academy. In the schismatic tradition of revolutionary politics, there was bitter disagreement with other revolutionary factions. Lewis was also opposed to what had, he believed, become an equally tyrannical orthodoxy, purveyed by influential critics

like Roger Fry and Clive Bell: that the only worthwhile contemporary art came from the opposite side of the Channel. No coincidence, seemed the implication, that *avant-garde* was a French term. English attempts to emulate continental advanced styles were dismissed, by Messrs. Bell and Fry, with a Bloomsbury curl of the lip, as mere 'provincialism'. In a battery of combative manifestos collected between bright puce covers under the title *BLAST*, Lewis countered the prevailing orthodoxy with accusations of 'feeble Europeanism, abasement of the miserable "intellectual" before anything coming from Paris.'[10] And so Vorticists found themselves, by reaction, pitted against Post-Impressionists; against Fauvists; against Cubists. Added to this was a need to differentiate the home-grown Vorticism from a rival insurgency of Europeans originating even further to the South.

Italian Futurism, like Vorticism, was a challenge to 'What Art Should Be'. It was radically anti-establishment, calling for the demolition of museums, libraries and academies and the sweeping away of the previous half millennium of art history – everything, in short, that was past. Even the coming European war, 'the world's only hygiene', would be delineated in a diagrammatic manifesto as a titanic conflict between 'Futurismo' and 'Passatismo'[11]. The movement had been launched in Milan, in a country, Lewis argued, less familiar than was Britain with products of the industrial revolution. This explained the enthusiasm of its leader, Filippo Tommaso Marinetti, 'adorned with diamond rings, gold chains and hundreds of flashing teeth'[12] – a hypercharged, Latin Jeremy Clarkson – for the internal combustion engine:

> We affirm that the world's magnificence has been enriched by a new beauty: the beauty of speed. A racing car whose hood is adorned with great pipes, like serpents of explosive breath – a roaring car that seems to ride on grapeshot is more beautiful than the *Victory of Samothrace* … We want to hymn the man at the wheel, who hurls the lance of his spirit across the Earth, along the circle of its orbit … We stand on the promontory of the centuries! … Why should we look back, when what we want is to break down the mysterious doors of the Impossible? Time and Space died yesterday. We already live in the absolute, because we have created eternal, omnipresent speed.[13]

So dynamic was this polemic and so expert its author at self-promotion and the capturing of newspaper headlines, that Futurism was fast becoming the new *avant-garde* orthodoxy in London. Accordingly, the Vorticists were forced to mount an opposition in order to consolidate their own rebel position and preserve their very identity. Ezra Pound slyly observed that the Futurist painters' attempts to express the 'beauty of speed' through multiplication of form – a blurred violinist[14], a little girl's feet repeated along a railing[15] and a centipedal dachshund[16] – was nothing new after all but merely an 'accelerated sort of impressionism'[17]. Lewis dismissed it more succinctly as 'Automobilism'[18].

As well as issuing manifestos, the Vorticists engaged in limited forms of direct action. They disrupted one Futurist meeting with barracking and fire-crackers. Their custom-made brass knuckledusters, however, were not, on that occasion, put to any practical use.

*

By the middle of the twentieth century, and after a second European war, there were, in a sense, two art establishments: the Royal Academy, and the beneficiaries of a new, wide-ranging, state-supported educational initiative. Traditionally anti-establishment Modernism had found powerful and influential supporters and the most extreme forms of advanced art were being actively sponsored by government-funded bodies. John Rothenstein, an enthusiastic advocate of modern British painting and sculpture, was director of the Tate Gallery, while Kenneth Clark, who had inherited the mantle of that earlier champion of the *avant-garde*, Roger Fry, was director of the National Gallery. Both men sat with Henry Moore and the Post-Impressionist painter Duncan Grant on the Council for the Encouragement of Music and the Arts which became the Arts Council at the end of the war. Meanwhile, under the chairmanship of Herbert Read, the Institute of Contemporary Art was formed in 1948 promising, thereby, that 'a wholly new aspect would be given to our life and civilisation.'[19] Its inaugural exhibition[20] was *Forty Years of Modern Art*. This was followed by the admirably inclusive *40,000 Years of Modern Art* which brought masterpieces of Modernism together with the fetishistic African and Oceanic artefacts that had inspired them. Art that had caused outraged sensation at a little gallery in Grafton Street forty years earlier, was granted an unimpeachably respectable forum when a major exhibition of Matisse and Picasso was put on by the British Council at the Victoria & Albert Museum. An equally unprecedented exhibition of Paul Klee was held under Clark's aegis at the National Gallery. And, as if to show that the latest trends in art were not the exclusive prerogative of intellectuals and critics, but were available to as wide a public as possible, the London County Council funded an open air exhibition of modern sculpture in Battersea Park. For the first time, the unorthodox had become a real challenge to 'the public conception of What Art Should Be In England.' So, in the Summer of 1949, when Sir Alfred Munnings, outgoing President of the Royal Academy, the institution which still represented that conception, rose unsteadily to his feet, allegedly after a few too many loyal toasts, at a lavish Burlington House banquet whose proceedings were being broadcast by wireless to the austerity-bound nation, he spoke as a member of a species threatened with extinction. Just as the early rebels had launched manifestos against what they regarded as the stultifying influence of the Royal Academy, so, for nearly twenty minutes Munnings delivered what was, in effect, a verbal manifesto aimed at the instigators and purveyors of 'so-called modern art'[21] currently infecting his students and 'putting all these

younger men out of their stride'. He denounced the monstrosities exhibited by the ICA, the Cubist and Fauvist works adorning the white walls of the Tate Gallery, and the 'bloated, heavy-weight monstrous nudes' by Henry Moore on show in Battersea Park. 'God help us', Sir Alfred fulminated, 'if all the race of women looked like that.' His slightly slurred, at times incoherent, but always passionately-felt remarks, struck a chord with the British public. Admittedly, there was offence in some quarters at his questionable state of sobriety and protests at his intemperate language, as when, having apologised in advance to the Archbishop of Canterbury, he expressed his preference for 'a damned bad failure, a bad, muddy old picture where somebody has tried ... to set down what they have seen' against anything coming from the School of Paris; as when he blamed the art critics for 'encouraging all this damned nonsense'; as when he recounted, with lubricious innuendo, an exchange he had had with the newly elected Extraordinary Member of the Academy, Mr Winston Churchill:

> ... he said to me, 'Alfred, if you met Picasso coming down the street, would you join with me in kicking his something, something, something ...?' I said, 'Yes sir, I would!'

But what won him the sympathy of the English public and occasioned the sacks of supportive letters arriving at the Royal Academy over the following weeks, was the injunction he mentioned having made to a group of students. It had the persuasive rhythm of a mantra:

> 'If you paint a tree, for God's sake try and make it look like a tree, and if you paint a sky, try and make it look like a sky ...'

Five years after Munnings' diatribe, a leading rebel painter from the beginning of the century, by then blind, published a book entitled *The Demon of Progress in the Arts*.[22] Wyndham Lewis warned that there was a limit beyond which, what he called, the 'extremist' painter, could not go. Although by no means aligning himself with the reactionary position of Munnings, he urged caution. Adopting a metaphor from the machine-mad Futurists of his own 'extremist' heyday, even anticipating the 'chicken run' sequence from the following year's motion picture, *Rebel Without a Cause*, Lewis suggested that there were reckless drivers who relished the excitement of driving along the edge of a cliff, but that

there was 'such a thing as driving *too near* the edge'[23], and that a brake must be applied 'to prevent ... the car, in which is our civilised life, plunging over the side of the precipice.'[24] Beyond a certain line, a certain degree of abstraction, a certain extreme, he argued, lay the danger of 'the exhibitionist extremist promoter driving the whole bag of tricks into a nihilistic nothingness or zero.'[25]

But in the second half of the twentieth century, beyond the edge of the cliff, forms of art came into being in which previously accepted aesthetic laws – like the law of gravity in the final freeze-frame of *Thelma and Louise* – ceased to have relevance. Beyond the extremes of abstraction, beyond the debates about representation and non-representation, an artist might dispense with paint and brush altogether, dispense with clay, wood, stone and metal. He might even dispense with getting his fingernails dirty and employ someone else to create that which he has conceived *the idea* for. 'The idea or concept is the most important aspect of the work', declared the American artist Sol leWitt in 1967:

> When an artist uses a conceptual form of art, it means that all of the planning and decisions are made beforehand and the execution is a perfunctory affair. The idea becomes a machine that makes the art.[26]

The logic flowing from this statement runs as follows: the 'real' work of art is the concept, that which is given form by the artist's assistant or manufacturer, under the artist's instructions and to the artist's specifications. The collector buys the artefact created by the manufacturer, but it is the concept of the artist that he is paying for. The logic flows further. In the unhappy event of the artefact being destroyed, by fire perhaps, the integrity of the artist's concept will still exist, unaffected by the flames. This fortunately makes it possible for an identical artefact to be manufactured of precisely equal validity to the first. But what must be remembered, is that the artist had as little to do with the destroyed artefact as he has to do with the artefact recreated. The artist was only ever exclusively responsible for the concept.

Damien Hirst is the best known of a generation of Young British Artists emerging in the late 1980s, some from Goldsmith's College, some from the Royal College. Hirst is certainly the most successful and, rivalled in the capacity to inspire public outrage only by Tracey Emin, the most provocative. There is something in his work – butterflies embedded in paint, cross-sectioned cattle in formaldehyde, house flies feeding on rotten meat – to offend everybody: animal rights protesters, vegetarians, the squeamish.

By the end of the twentieth century, the advance guard of the modern movement in this country had advanced so far it could be said to have arrived. Having arrived – with arguably no further place to go – it remained, perforce, established. With the sponsorship and endorsement of Sir Nicholas Serrota at Tate Britain enabling domination of the Turner Prize, enriched by the lavish economic patronage of the collector Charles Saatchi, even with the blessing of the traditional forces of conservatism, implied by the Royal Academy's hosting the blockbuster *Sensation* exhibition in 1997, the YBAs of so-called 'BritArt' represented the new artistic establishment. The dynamics of power and rebellion demanded a reaction. Creation of an Establishment called for a contrary Anti-Establishment movement. In January 1999, Stuckism was born.

2

The *Newsnight* programme, BBC 2, Tuesday 19 October 1999:

On Jeremy Paxman's left sits Brad Lochore, and behind Lochore's chair is a white plastic detergent bottle on a white plinth made of cardboard. In contrast to the austerity of Lochore's side of the platform, Charles Thomson, sitting on Paxman's right, is surrounded by brightly coloured canvases. Behind him is a portrait of a man in a blond beehive wig, by Ella Guru. Next to that is a picture by Frances Castle, called *Cameras are watching over you*, showing what appears to be a human figure, in crouched skiing posture, wearing a blue jump suit complete with long rabbit ears. Leaning against Thomson's chair is *Cat and Dog Underwater* by Wolf Howard, and a work by Philip Absolon in black, white and red featuring skeletons. Also revealed, whenever the camera pulls back to widen the shot is a version of a Gainsborough portrait by Thomson himself.

> PAXMAN: Well we are joined here in the studio by two artists, Brad Lochore who is a conceptual artist and by Charles Thomson who is one of the founders of ah ... of Stuckism.

Using the brisk and business-like politeness he normally reserves for inviting a Cabinet Minister to concede his policies to be fundamentally unsound, his credibility in tatters, Paxman turns to Thomson.

> PAXMAN: Just explain what Stuckism is please.
> THOMSON: Stuckism is a movement that simply says that the best way to do art at the moment is painting pictures.
> PAXMAN: And it's called Stuckism because ...?
> THOMSON: Stuckism because Tracey Emin said of my friend Billy Childish[27] that he was stuck and his paintings were stuck, stuck, stuck. And I thought in the line of art history that an insult is a good title – as Impressionism for example – that we should call ourselves Stuckists.

The defiant transformation of a derisory brand into a badge of pride has indeed a respectable tradition. It was Louis Leroy in 1874 who scornfully added the suffix to Monet's perfunctory title 'Impression: Sunrise' and invented the term Impressionism, forthwith embraced by the painters themselves. At the Autumn Salon of 1905, the critic Louis

38

Vauxcelles caught sight of a quatrocento-style statue surrounded by garishly painted canvases by Matisse, Derain, Vlaminck and Rouault, and remarked: 'Donatello au milieu des fauves!'[28] and 'Fauves' was how the artists concerned subsequently styled themselves. The coinage of the term 'Cubism' had a similarly pejorative pedigree originating in 1908, when an exasperated member of the Salon des Indépendents hanging committee exclaimed as yet another canvas by George Braque was brought in: 'Encore des cubes! assez de cubisme!'[29]

Having listened to Thomson explain the comparable genesis of 'Stuckism', Paxman introduces the subject of the Turner Prize. The four shortlisted artists' works have just gone on show at Tate Britain. Steve McQueen will be the eventual winner for Deadpan, a recreation of the most famous Buster Keaton stunt from Steamboat Bill Jr., filmed from multiple angles, and for Drumroll. 'To make this work', the Tate's press-release explains, 'the artist rolled a metal barrel through the streets of Manhattan, with cameras mounted in the top, bottom and side. The artist can be heard above the ambient noise of the city and that of the rolling barrel itself, apologising to passers-by for the obstruction. The work engages with some of McQueen's major themes such as journeying, movement, dislocation and exile.' Exploring an analogy between the processes of cleaning clothes and developing pictures, Steven Pippin has been shortlisted for Laundromat-Locomotion, a row of twelve washing machines converted into cameras, recording, with the use of tripwires, the movements of himself and of a horse and rider, in homage to the photographic pioneer, Eadweard Muybridge. Identical twins Jane and Louise Wilson are exhibiting Stasi City and Gamma, four-screen video projections of the interiors of abandoned building complexes. 'The atmosphere was really quite banal,' the twins explain, 'but there was also an element of theatricality.' But the 1999 Turner Prize will be best remembered for the short-listed artist who does not win, and for the work that is a cartoonist's dream and the answer to a tabloid editor's prayers: Tracey Emin's My Bed. The self-explanatory title refers to 'an installation including the artist's bed, soiled sheets, bloodied underwear, empty vodka bottles, discarded tissues, fag ends, used condoms and other post-coital detritus.'[30]

> PAXMAN: So I take it from that you don't rate any of those [on the] Turner Prize short list.
> THOMSON: Not as art. No. I think that there are little bits of interesting photography, interesting cinema that can go into another arena. The bed, the knickers are obviously quite … completely absurd and the video by the Wilson twins I've seen something similar at the Serpentine and let me assure you it's totally boring.
> PAXMAN: No, I've seen it. I wouldn't say it was totally boring, it was …
> THOMSON: Well it repeats every five minutes, so if you're there for more than five minutes …
> PAXMAN: Well you're not supposed to spend all evening there.

The manifesto 'Handy Hints' defines the Stuckist position on such usage of video in art: 'By boring we mean it could be there or not be there and it would make no difference, but it would be better if it wasn't.' However, unwilling to bandy words further on comparison of their respective boredom thresholds, Paxman turns from the Stuckist to the Conceptualist.

> PAXMAN: Now … what do you reckon?
> LOCHORE: Well, I think it's indisputably art. Whether it's good or bad art is another question. It's art and er … to say it's not, is, you know …

PAXMAN: Why is it art?

LOCHORE: It's art because it really is talking about our experiences in the world and how to deal with those experiences … and they're very complex experiences and taking them outside of the everyday and place them in another context. It might not necessarily be very good. It might be very … very bad, but erm … it's … it's definitely art.

THOMSON: Well it's not indisputably art because I'm disputing it. So it is disputable … I'm afraid. We dispute it very strongly and there's a lot of people who dispute it, in fact I would say that most people in this country dispute it.

LOCHORE: Well they may well dispute it but the question is if it … if people say it's art, it's art.

THOMSON: Well I think that is absolute rubbish.

PAXMAN: So you can say anything is art?

THOMSON: You just have.

LOCHORE: You could say everything is art …

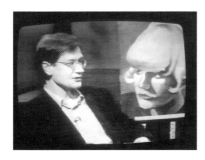

At this point, with the camera focused on Lochore, Thomson makes two interjections. One is vocal and off-camera.

THOMSON: Is my shoe art?

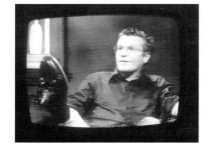

The other, simultaneous, interjection is visual. With immaculately polished timing, Thomson's immaculately polished black Oxford is raised into camera shot and, for a split-second, held in front of Lochore's bemused gaze, awaiting his decision as to whether it is, or is not, to be deemed art. This is a key moment. The manifesto, 'Handy Hints', enlarges upon the subject of demarcation between fine art and footwear: 'It is not fascism to name a brick a brick, a shoe a shoe, a horse a horse or a painting as art … The painting of pictures is the painting of pictures. People agree that a shoe is a shoe and a brick is a brick, not out of dogma or close-mindedness but to avoid walking around with bricks strapped to their feet … All things are qualitatively different. A shoe is not art because of its inherent shoeyness and usefulness as a kind of "foot-glove". Like wise a blancmange isn't a shoe. This isn't a dilemma for most people and, until relatively recently, was not a problem for artists.' In the heat of debate and the studio lights of the *Newsnight* studio, and despite the startling booby-trap of Thomson's interruption, Lochore remains admirably consistent with his earlier declaration that 'if people say it's art, it's art', and comes to his decision as to the artistic status of Thomson's shoe.

LOCHORE: If you say it is. I have to then judge it on those terms.

His opponent is unimpressed.

THOMSON: I think that's a totally ridiculous argument.
LOCHORE: Well …
THOMSON: I've never heard anything so ludicrous in my life before.

Lochore attempts to insinuate another argument into the debate.

LOCHORE: Well it's sort of like saying … erm you know, a bad experience is not an experience …
THOMSON: No it's not. It's not like saying that at all.

Lochore opens his mouth but does not say anything.

THOMSON: Well, what we're saying is that there are certain things in art which are valid. I think a lot of the art we are seeing there [on the Turner Prize short list] is totally cynical, exploitative, negative and totally idiotic and it exists for an élite. It's done by an élite.
PAXMAN: That doesn't mean it's not art.
THOMSON: No, it doesn't indeed, but I think that for most people it means nothing, and I would actually say that it's not art anyway.
PAXMAN: But are you so strict in this that you say that art can only be painting, it can only be this sort of thing …

Gesturing at the two pictures hanging behind Thomson's chair, Paxman comes perilously close to using a turn of phrase which might be thought inappropriate from the mouth of an eminent BBC 2 presenter.

PAXMAN: … which frankly strikes me as rather taking the p… er taking the mickey.
THOMSON: No it's not. It's not.
PAXMAN: Yes, come on it is. It quite clearly is.
THOMSON: No it's not.
PAXMAN: Oh it's not? I'm so sorry
THOMSON: I mean this [painting by Ella Guru] is about someone's concerns.

Ohio-born Ella Guru has been a member of the pop-group *Voodoo Queens*, a waitress, go-go dancer, stripper and web-site designer. She claims to have frequented fetish clubs and spanked 'hungry gentlemen'. She once had lunch in New York with Quentin Crisp, who thought her 'weird'. Her entry in the 2000 Stuckist exhibition catalogue will read: 'Often paints men and women in beehive wigs, because she likes men in drag and met her fiancé Sexton Ming when he was a transvestite. Paints quickly. Likes traditional painting. More inspired by a trip to the National Gallery than Tate Modern.'

THOMSON: It's about people involved in transvestitism and the difficulties of that kind of experience.

PAXMAN: I see.

Thomson gestures to the other painting, by Frances Castle.

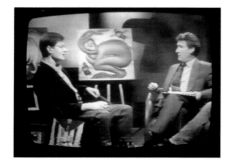

THOMSON: This person works all day doing computer animation and I think at the end of the day she probably feels like that.
PAXMAN: But it looks like a blue rabbit
THOMSON: Yes, well she probably feels like a blue rabbit. But I do think it's genuine and I think it comes from her heart.

Paxman turns back to Lochore.

PAXMAN: All right, you have brought with you a work here behind you by a pal of yours – a cardboard plinth that appears to have a detergent bottle on the top of it. Yes? Is it a detergent bottle?
LOCHORE: Yes, it's by a good friend of mine, Neil Cummings, who is an artist ...

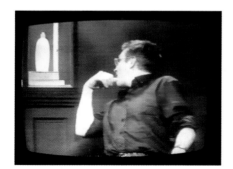

Neil Cummings believes that there are already enough 'things' in the world without the need to create anything more. He therefore makes art using only recyclable materials such as the white plastic detergent bottle on the white cardboard plinth.

LOCHORE: ... and I saw it at a show he was in and I ... I loved it so much I offered to swap it for a painting and he agreed and I love having it around the house. What it does for me is it reminds me of the sort of vanity of shopping and the vanity of ... you know ... the way in which we construct values and meanings in the world. It's er ... it's a very humorous, funny piece.

Evidently not sharing his appreciation of the humorous and funny piece, Thomson smiles broadly as Lochore concludes his exposition.

LOCHORE: Every time I go into a shop and I look at things on display now I sort of remind myself that the display is constructed.

Paxman turns back to Thomson.

> PAXMAN: Now why is *that* not just as valid as somebody painting themselves as a blue rabbit?
> THOMSON: I think that's very cynical because once upon a time people would have tried to say something genuine. I don't think that is saying something genuine. I think it's a negation of values. Once upon a time you'd have had a figure there that represented something. You'd have had Shakespeare or Beethoven and I think this person is basically saying: now a detergent bottle is just as good as Shakespeare and Beethoven.

Paxman, for a moment, becomes uncharacteristically incoherent.

> PAXMAN: He's not saying just … What is it say …
> LOCHORE: The bottle itself is like a figure. It's got a very sort of sexy shape …
> THOMSON: But it's not a figure.
> LOCHORE: … containing detergent but it's eroticised here in this … in this sculpture.
> THOMSON: I don't find it very erotic I must say.
> LOCHORE: But the shape of the bottle is very curved …
> THOMSON: No, not for me. I prefer a dip in the middle with the waist.
> PAXMAN: But … I mean … if we are to take your movement at face value which you are inviting us to do …
> THOMSON: No, you must.
> PAXMAN: You are completely genuine?
> THOMSON: Yes.
> PAXMAN: It's not an elaborate hoax?
> THOMSON: No, people keep on saying is this a joke. The joke is that the Tate Gallery will exhibit dirty knickers. That's the *joke*. You know, the fact that we question that, people say are you joking. We are *not* joking.

During the following year's Turner Prize awards the Stuckists will emphasise this anomaly by picketing the steps of the Tate Gallery dressed as clowns. Thomson will be interviewed wearing a bright yellow baggy suit, red nose, giant pink-rimmed sunglasses and a multi-coloured wig. 'Everything seems topsy-turvy', he will explain, 'the people who do the Turner show, they appear in normal clothes and they're a joke so the corollary is if you want to be taken seriously you look like an idiot.' The prize of a custard pie will be awarded, but not presented, to Charles Saatchi, *Art Clown of the Year 2000*, 'for outstanding idiocy in the visual arts.' Sir Nicholas Serota will be a subsequent winner, for three years running.

> PAXMAN: Had [the Stuckist] attitude [to *avant-garde* art] been prevalent a hundred years ago, Impressionism wouldn't have happened. Cubism would never have happened …
> THOMSON: It would, because they were painting pictures. That's exactly what we're saying.
> PAXMAN: I see. Would Henry Moore have happened?
> THOMSON: Hopefully not, no!

Paxman buries his face in his hands and appears to shake with laughter.

> LOCHORE: But Charles, your claims that all of these works are very insincere ... I mean I think that all of those artists at the Tate, whether you like the work or not, are very sincere ... and, and ... In the same way that you're being sincere as well. I think that they're just reflecting on certain experiences that they have of the world ...

Paxman collects himself briskly.

> PAXMAN: All right, this one's going to run and run. I'm going to stop you there. Thank you both very much.

3

The television viewers who witnessed the *Newsnight* debate in October 1999 were, in the main, probably not so very different in their attitude to the subject from the wireless listeners who tuned in to hear Sir Alfred Munnings rant against 'so-called Modern Art' 50 years before. That audience in turn would have had much in common with large numbers of the public who flocked to the Grafton Galleries in 1910, to laugh at the Post-Impressionists. The English public has always enjoyed seeing the pretensions of high, or would-be high, culture punctured. They had felt a sense of complicity with Churchill and Munnings in wanting to kick Picasso's backside. Now Thomson was performing the same service on their behalf against Tracey Emin and the other disturbing stars of BritArt. For one sublime moment, it even appeared as though he were proffering his own size eleven shoe for the job.

'My horses may be all wrong', Munnings had declared, comparing his favoured equestrian subject matter with a statue of the 'Madonna and Child' by Henry Moore, 'we may *all* be wrong', he pursued, 'but I'm damned sure *that* isn't right.' And the *Newsnight* audience, while they may have harboured doubts about Frances Castle's blue rabbit, would have been to a man and woman, sympathetic with Thomson's derision at Tracey Emin's bed, his slighting evaluation of Neil Cummings' detergent bottle and his dismissal of Lochore's defence of Conceptualism as 'absolute rubbish.' Stuckism is very much allied to public suspicion of contemporary art. 'Many people see so-called contemporary art in a gallery but it seems to them to be nothing but a pile of rubbish', declared one manifesto:

> However, because it is in a gallery and has been taken seriously by the critics, these people conclude that it can't be rubbish, that they have missed the point and they are stupid. We have good news for these people: they are not.[31]

It should not be assumed that Stuckist appeal to the conservative values of the man in the street in any way equates the views of Childish and Thomson with Sir Alfred Munnings' views on Modernism (this, despite the seeming concurrence of Thomson with Munnings on the subject of Henry Moore). Like the blind seer Wyndham Lewis in the 1950s, the co-authors of the Stuckist manifestos express no opposition to Modernism *per se*, only to Modernism that has crossed the edge of the cliff – to Modernism that,

'through the course of the twentieth century … has progressively lost its way, until finally toppling into the bottomless pit of Post Modern balderdash.'[32]

There is an attractively simple, inescapably logical, line of argument to many Stuckist manifesto statements. That line of argument could be termed mere common sense but is nevertheless devastating in its capacity to demolish the pretensions of Conceptualism. 'Artists who don't paint aren't artists'[33], might seem a truism, but in the light of Damien Hirst's working practice it becomes a fundamental tenet of the debate. Asked why he no longer made his 'Spot Paintings' himself, Hirst explained that he found the process of painting the coloured spots onto canvas boring:

> I only ever made five spot paintings myself. Personally. I can paint spots. But when I started painting the spots I knew exactly where it was going. I knew exactly what was going to happen. I couldn't be fucking arsed doing it. And I employed people. And my spots I painted are shite. They're shit. They're shit compared to … The best person who ever painted spots for me was Rachel. She's brilliant. Absolutely fucking brilliant. The best spot painting you can have by me is one painted by Rachel.[34]

The extraordinary logic of this last sentence is elaborated in Hirst's account of a conversation with another person who had endured the tedium of painting for him. This provides an illuminating fable, encapsulating not only the economics of BritArt, but also the inherent wealth of absurdity that can be mined from it:

> I had an argument with [another] assistant who used to paint my spots. When she was leaving, and she was nervous, she said, 'Well, I want a spot painting. I've painted loads for you. I've painted these spot paintings for a year, and I want one.' A year in the studio, getting paid a fiver, a tenner an hour, whatever it is. So I said, 'I'll give you a cheque for seventy thousand quid if you like. Why don't I just do that? Because you know you're going to sell it straight away. You know how to do it. Just make one of your own.' And she said, 'No, I want one of yours.' But the only difference between one painted by her and one of mine is the money.[35]

And, lest the statement on painting might be thought to exclude the three-dimensional in art from Stuckist consideration, another manifesto declared: 'Sculptors who don't sculpt aren't sculptors.'[36] This would seem an equally facile observation, were it not for the following insight into Hirst's creative processes. *Hymn* was copied from a small mass-produced plastic anatomical toy originally designed by a man called Norman Emms[37] and retailed as 'The Child Scientist':

> The guy at the foundry, when I went in there, he says, 'What d'you want?' So I gave him the toy and said, I want it made this big, twenty feet, with a base this height.' And he said, 'What do you want it to look like at the end?' And I said, 'Plastic!' He nearly had a heart attack. He said, 'But it's a bronze.' I said, 'I want it to look like plastic.' 'Well, why do you want it to be bronze?' 'Because I want it to be grand, I want it to be bronze.'[38]

Having made the three necessary decisions as to size, material and general appearance, and leaving the problem-solving and grandeur to the anonymous 'guy at the foundry', the artist awaited the completion of his order:

> And just when [the guy] finished making it, he phoned me up and he's like, 'C'mon, we can do some great patinas … We can do a really great red patina.' I said, 'What, bright red? Like plastic?' He said, 'No. Not like plastic.' 'Well, can you make it look like plastic?' And in the end, he thought it was great and he really liked it.

As did Charles Saatchi, enough to pay the artist one million pounds for it.

<p style="text-align:center">*</p>

At the time of writing, the world is coming to terms with news that a substantial number of works from Saatchi's collection of BritArt have been destroyed. In the early hours of Monday 24 May 2004, one of the warehouses on an industrial estate in Leyton, East London, was gutted by fire. It belonged to a company called Momart, the country's leading firm of art handlers. Saatchi himself is said to be 'devastated'. First reports suggested that a 22 foot high replica of the Spastics Society collection box – another Damien Hirst sculpture that he did not sculpt – entitled *Charity*, had been lost to the flames, but it was later found elsewhere unscathed. Tracey Emin's *Everyone I have Ever Slept With 1963-1995*, however, perished. It was a blue tent, the interior appliquéd with names of the 102 people the artist had shared a bed with since her birth. These included her mother, grandmother, twin brother and two aborted foetuses. There were also the names of all her former lovers, including that of the co-founder of the Stuckist Movement, Billy Childish.

In all, it is feared that something in the region of a hundred works belonging to Mr Saatchi were destroyed. 'This is probably the worst thing one could imagine'[39], he declared. The critic Richard Cork, finding the word Saatchi was searching for, pronounced it to be 'apocalyptic'[40]. As yet it is not known how the fire started, but Jake Chapman, co-creator with his brother Dinos, of a vast and gruesome assemblage of tiny figures called *Hell* – ironically, also burned – is quoted as holding 'God personally responsible.'[41]

BritArt has occasionally fallen victim to deliberate damage in the past. Such studied vandalism is part of a tradition in which individual acts of protest, for whatever reason, have been perpetrated against contemporary art throughout the twentieth century: Mrs Mary Wood's suffragette cleaver attack on Sargent's portrait of Henry James in the Royal Academy Summer exhibition of 1914; a young Hungarian artist's mangling of Reg Butler's prize-winning model for a monument to 'The Unknown Political Prisoner', at the Tate Gallery in 1953; the daubing of red paint across Carl André's *Equivalent VIII*, popularly known as 'the Tate's pile of bricks', in 1976. So, in 1994 Mark Bridger, a disaffected artist, poured ink into the vitrine containing a dead lamb in formaldehyde at the Serpentine Gallery – Damien Hirst's *Away from the Flock* – and thereby re-titled it *Black Sheep*. In 1997, Marcus Harvey's gigantic grisaille portrait of Myra Hindley, pixilated with a child's hand-print, was splashed with ink and pelted with eggs at the Burlington House *Sensation* Exhibition. And on 24 October 1999, just five days after the *Newsnight* debate was aired, JJ Xi and Yuan Chai, two Chinese performance artists, stripped to the waist and staged an 'act of expression' at Tate Britain, which involved romping about on the year's most notorious Turner Prize-nominated exhibit. The duo entitled their artistic intervention: *Two Men Jump into Tracey's Bed*. The incident was not without interest,

offering as it did the first inkling of what seemed to be a counter-reactionary trend. While Xi and Chai may have taken issue with Emin's work as being somehow incomplete without their contribution, they made clear where their allegiance did *not* lie. Slogans adorned their naked upper bodies. Most, unhelpfully, were in Chinese. But across their backs ran the words: 'Anti-Stuckist'.

The Stuckists have never engaged in such activity. They have, instead, confined themselves to more articulate, witty and lawful forms of protest against the BritArt establishment: the clown-picketing of the Turner Prize; the lodging of a complaint with the Office of Fair Trading against Charles Saatchi on the grounds that his dominant position in the art market has led to unfair competition, mitigating against consumer choice; and, of course, the literate, time-honoured medium of the Manifesto.

Amid a plethora of expert opinion on the fire's probable implications for art history, ranging from 'tragic' and 'disastrous' on one side, to mockery and unabashed *schadenfreude* on the other, Rachel Campbell-Johnson, chief art critic of *The Times*, sounded a balanced note of comfort: 'Fortunately, the most representative pieces by the Brit pack – the shark in formaldehyde, the head filled with blood, the unmade bed – remain safely in the Saatchi Gallery in City Hall.'[42] But she went on to say that 'BritArt is over as a movement.' Saatchi might even consider himself lucky because the destruction of a sizeable number of works will maintain the market value of those that survive, works whose value would otherwise be in danger of plummeting due to the vagaries of fashion and not least because some of them are 'famously unstable and decaying.'

It remains to be seen whether the Momart warehouse blaze indeed represents the funeral pyre of BritArt and, if so, for how long Stuckism will maintain a valuable function of reaction from its outpost on the edge.

Paul O'Keeffe July 2004

[1] David Bomberg, 'The Bomberg Papers' *X: A Quarterly Review* I (June 1960) p.185

[2] *The New Age* 24/11/10

[3] 'Paint Run Mad: Post-Impressionists at Grafton Galleries' *Daily Express* 9/11/10.

[4] *The Morning Post* 7/11/10

[5] *The Graphic* 26/11/10

[6] *The New Age* op cit.

[7] Until October 1912 when the Second Post-Impressionist Exhibition opened, also at the Grafton Galleries.

[8] 'Exhibition of Works by the Italian Futurist Painters', Sackville Gallery.

[9] *Blast* London: John Lane, 1914 [p7]

[10] *ibid*, p.34.

[11] *Futurist Synthesis of the War*: From the Milanese Cell, September 20 1914, Directory of the Futurist Movement: Corso Venezia, 61 – MILAN.

[12] Douglas Goldring *South Lodge: Reminiscences of Violet Hunt, Ford Madox Ford and the English Review Circle* London: Constable, 1943, p.64

[13] F.T. Marinetti 'The Founding and Manifesto of Futurism 1909' *Futurist Manifestos* ed. Umbro Apollonio, London: Thames & Hudson 1973, pp.21-2

[14] *The Violinist's Hands* by Giacomo Balla 1912 (E. Estorick collection, London.)

[15] *Little Girl Running on a Balcony* by Giacomo Balla 1912 (Civica Galleria d'Arte Moderna, Milan)

[16] *Dynamism of a Dog on a Leash* by Giacomo Balla 1912 (MOMA, New York)

[17] 'Vortex Pound' *Blast* London: John Lane, 1914 p.154

[18] 'Automobilism' *The New Weekly*, II, no. 1, 20/6/14, p.13.

[19] *The Times* 14/2/48

[20] At the Academy Hall Cinema, Oxford Street.

[21] This, and all subsequent quotations from Munnings' speech, from *Munnings vs The Moderns,* Manchester City Art Galleries, 1986.

[22] Methuen, 1954.

[23] p.32

[24] p.33

[25] ibid

[26] Sol LeWitt, 'Paragraphs on Conceptual Art' *Artforum* Summer 1967. Quoted Michael Archer *Art Since 1960* London: Thames & Hudson. 1997 p.69.

[27] formerly Steve Hamper.

[28] 'Donatello among the wild beasts!'

[29] "More cubes! Enough of cubism!" quoted by Frank Rutter, *Evolution in Modern Art: A Study of Modern Painting 1870-1925* London: Harrap, 1926, p.80

[30] Mandy Merck 'Bedtime' *The Art of Tracey Emin* ed. Mandy Merck and Chris Townsend, London: Thames & Hudson, 2002, p.119

[31] 'The Decrepitude of the Critic'

[32] 'Remodernism: Towards a new spirituality in art'

[33] 'The Stuckist Manifesto'

[34] Damien Hirst and Gordon Burn *On the Way to Work* London: Faber & Faber, 2001 p.90

[35] ibid. p.82.

[36] 'Handy Hints' *The Stuckists*, 2000 Victoria Press

[37] Emms later sued Hirst, successfully, for plagiarism.

[38] op.cit. p.147-148

[39] *Guardian* 26/5/04 p.1

[40] Speaking on BBC Radio 4's *Front Row* in the week following the fire.

[41] *Independent* 27/5/04 p.15

[42] *The Times* 26/5/04 p.3

Opposite IS MY SHOE ART? Charles Thomson 1999 oil on canvas 101.6 x 76.2cm

IS MY Shoe ART ?

IF You SAY it IS

I'VE NEVER HEARD anyTHING more LUDICROUS IN my LIFE BEFORE

PHILIP ABSOLON

Philip Absolon lives and paints in a bedsit in Rochester, Kent, is dyslexic and partial to blonde girls.

24.11.60	Born Erith, Kent. Great-great-grandson of Victorian watercolourist, John Absolon (1815-95).
1971-76	Rede School, Strood and Educational Special Unit, Chatham, Kent.
1977-79	Medway College of Art & Design, Foundation. Second year ruined by a blonde girl.
1979-82	Epsom College of Art, Diploma. Paintings thrown into skip on Principal's orders.
1982-93	Unemployed/job training schemes for office and computer work.
1984	Applied to Slade School of Art because Augustus John went there. Rejected.
1987	Applied to Royal College of Art. Submitted pictures of cats. Rejected.
1993-94	Fine Art Access course, Maidstone College of Art.
1994	Accepted on a part-time degree course at KIAD (Kent Institute of Art & Design). Unable to take up the course because of financial difficulties. Then awarded a grant, so applied for full-time degree course. Rejected.
1994	Attended life drawing classes at Rochester Adult Education Centre.
1999	Accepted for NVQ in horse care. Unable to complete because of mandatory Government Project Work placement. Founder member of the Stuckists art group.
2003-4	Artist-in-Residence, Rochester Adult Education Centre, Kent.

Travels by train through Europe visiting palaces and art museums. Fascinated by German Hohenzollern Empire (1871-1918). Likes cats, dogs, horses and the Arts Club, Mayfair. Attends courses on sculpture, life drawing and painting daily. "I've been encouraged to keep going by Billy Childish during difficult times."

Job Club: "They were all real people on a government unemployed scheme. They were builders apart from me, and they didn't want to be there. We'd all been doing it so long that I thought we would end up dead still doing it. I also disguised them because I didn't want to get beaten up. They're all portraits. I'm the middle one."

"I do lots of drawing from life. I've drawn continuously since I was sixteen. I like to watch cats moving and draw them. Then I enlarge the drawing on a photocopier and trace it onto the canvas using dressmaker's tracing paper. I usually paint 8-10pm every night: a painting takes up to a month."

Web site www.absolon.org.uk

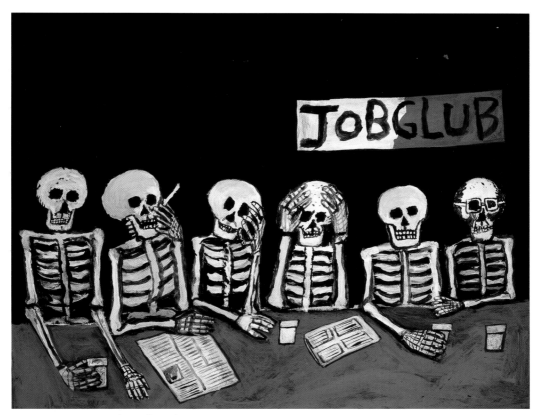

JOB CLUB *1997 acrylic on board 46.6 x 55.6cm*

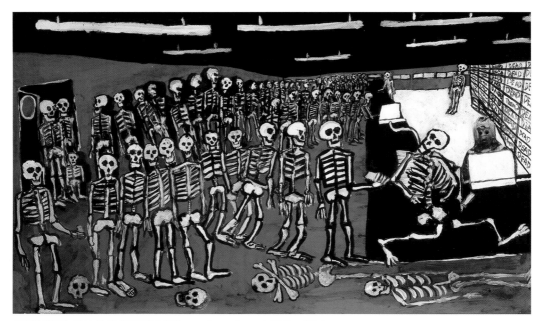

SHOWING HIM THE ROPES *1997 acrylic on board 47.3 x 78.6cm*

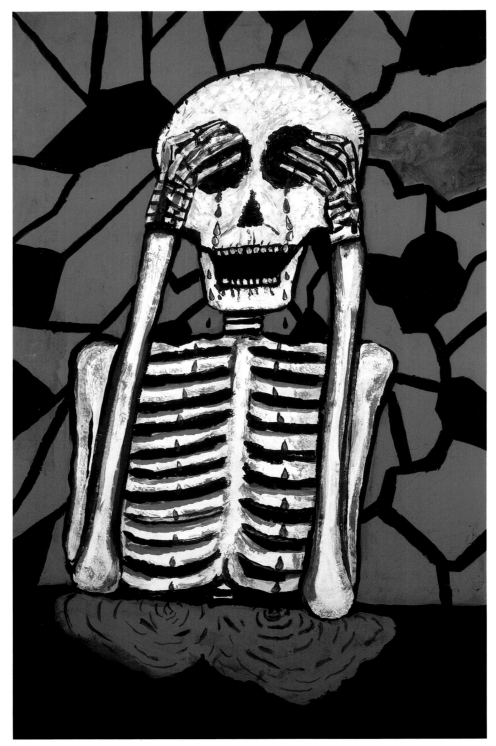

BREAKDOWN *1997 acrylic on board 73.1 x 46.1cm*

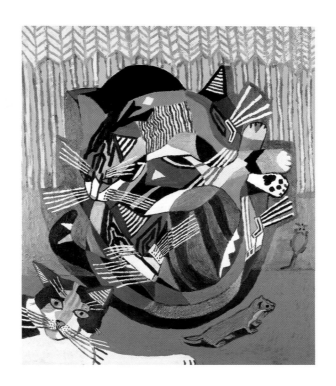

CAT FOUR (CAT, MOUSE
AND WEASEL)
2000
oil on canvas
60.7 x 50.7cm

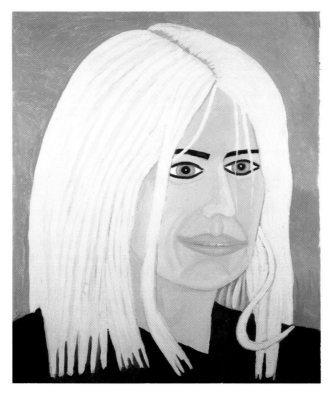

STABLE GIRL
1999
acrylic on canvas
76.3 x 61cm

FRANCES CASTLE

Lives in Finsbury Park, London and works in computer games graphics.

17.2.66	Born, Kingston, Surrey.
1977-82	Putney Park Secondary School.
1983-85	Foundation course, Richmond College.
1985-87	HND in Illustration, Lincoln College.
1987-95	Did loads of things – cleaning in hostel (San Francisco), selling jewellery, illustration, bar work.
1995-96	Postgraduate Diploma, Computer Imaging and Animation, Guildhall.
1996-	3D Graphics for computer games (mainly Playstation) including Harry Potter and Disney.
1999	Founder member of The Stuckists art group.
2003	Won Ningyoushi competition for toy figure design.

Makes indie electronic music at home on a computer. Full length CD *Johnny, Where's My Purse?* released by Black Bean and Placenta label, California. Works very long hours to pay the mortgage. Collectors of her work include Norman Cook (Fatboy Slim). Has been camping with her boyfriend with Sexton Ming and Ella Guru in Dorset – "it was like a Mike Leigh film".

"*Cameras Watching Over You* is the thought that every minute of our time is being monitored now, so you're walking down the street and you're being watched by CCTV. It's to do with the paranoia you might feel. I do probably identify with the blue rabbit, because I had a rabbit as a child. It's the vulnerability. It was the language of characters I was using at the time – cartoon-inspired, semi-sexual furry animals inspired by random individuals that I meet on a day to day basis. My paintings are strong graphic images and I don't really want to harp on about what they mean.

"I start with a sketch in a sketchbook, and I usually just do one sketch and use that one. I have it in my head before and put it straight down on paper – once it's on the paper I don't usually re-work the shape. I know exactly what I want to do. I then take it onto canvas, sketch it freehand with oils, then use collage for the background, builder's filler for the texture and oil paint for the details and colour over a period of a month or more. It's a completely different form of expression to what I do at work, the tools are different, but I'm still dealing with form and colour."

Art website www.caperstreet.com
Music website www.transistorsix.co.uk

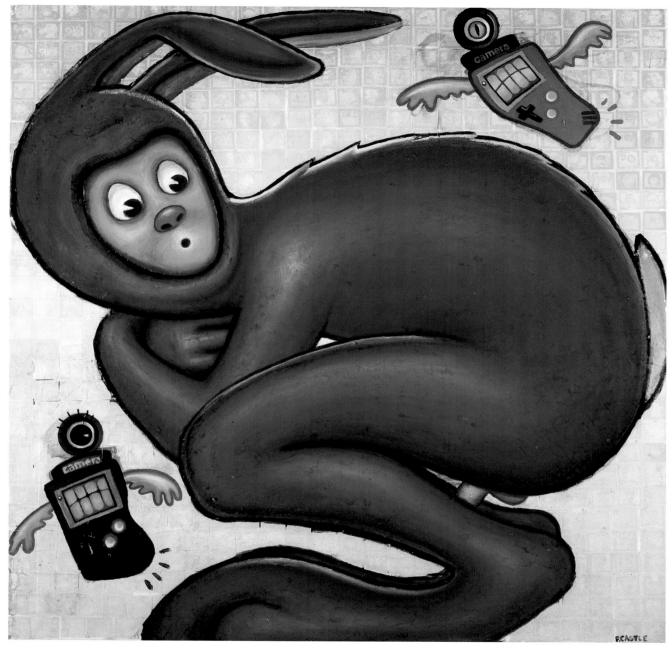

CAMERAS WATCHING OVER YOU *1999 mixed media 76.2 x 76cm*

GREEN VEGETABLE MONSTER *1997 mixed media 137 x 111.5cm*

STINGER 2000 oil on canvas 50.8 x 40.4cm

ELSA DAX

Lives between Paris and Camden with architect husband, John Kerr. Passionate about Greek mythology.

14.5.72	Born Paris, France.
1984-89	Paul Valery School, then Paris Sophie Germain.
1989-90	University Sorbonne, D.E.U.G. (Russian).
1990-94	Paris VIII University, MA (Cinema).
1995	Production Assistant for film *Whistler, an American in Paris*.
1996	Production Assistant Musée d'Orsay, Librarian in Pompidou Centre.
1997	Production Assistant Ciné Lumiere, French Institute, London.
1998-	TV advertisement editor, Extreme Information TV.
1999	Editor Cannes Advertisement Festival.
2000	Exhibited Stuckists *Real Turner Prize Show*, Pure Gallery, Shoreditch.
2001	Founded The Paris Stuckists. Curated *Stuckist Vernissage* (Stuckist Paintings) at Musée d'Adzac, XIV arrondisement, Paris.

Mother of two young girls, Sophia and Jeanne. Bonne vivante. Médoc, Cordier, écrevisses, wild pigeon, cèpes mushrooms. Walks in the Bois Vincennes and by Camden canal. Part-time smoker. Solo shows in Paris and London. Puts on make-up on bus journeys – "I can't paint on buses, so I have the pleasure of painting myself."

Venus and Mars: "My aim is to paint all the Greek and Roman gods and goddesses. I've been working on this series for eight years; it will probably take me another eight years to complete. I try to penetrate with my imagination into the essence of the god or goddess. After painting them I feel as if I'm protected by these deities on a spiritual level. When I painted Venus I felt quite happy and relaxed; Mars made me feel like Churchill – the warrior, the struggle. Venus and Mars don't appear to be intimate, but there is a subtle sexual union. His penis is about to enter her vagina."

"My research is based on two things. The first thing I do is to read through academic books about the god/goddess, and look superficially at sculptures and past illustrations. The second thing is to look at infant picture books; I like the simple technique – there is nothing pretentious. I plan out the painting in my head for a few weeks and get a rough idea. I start the painting by locating the main character. The rest of it spreads out around that. I work all over the picture and – this is incredible – discover images like you might discover figures in a cloud. A painting takes me a good three months."

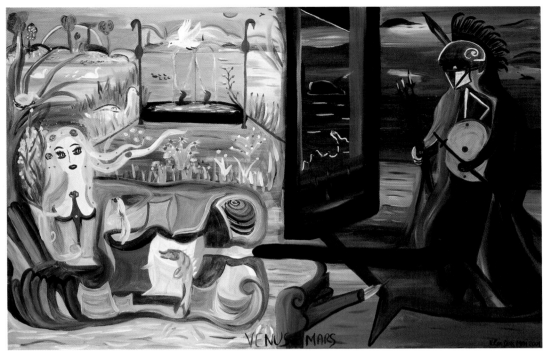

VENUS AND MARS *2001 oil on canvas 60.2 x 91.3cm*

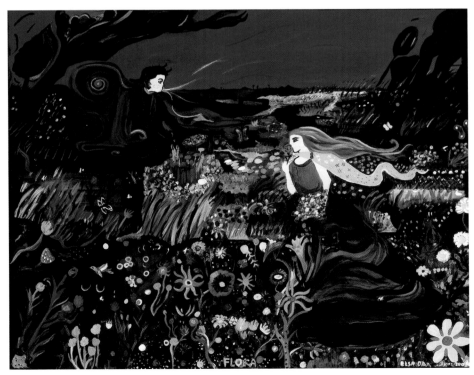

FLORA *2004 acrylic on canvas 61 x 76cm*

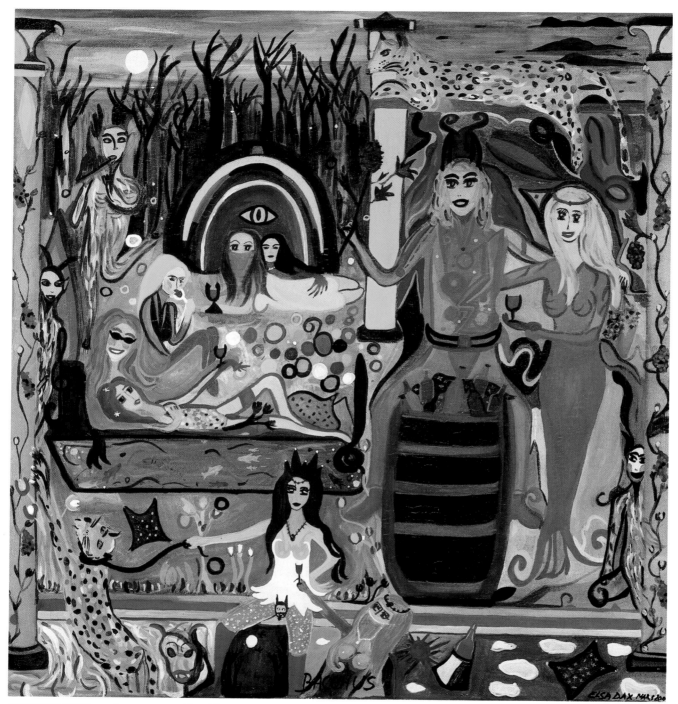

BACCHUS *2000 acrylic on canvas 67 x 62cm*

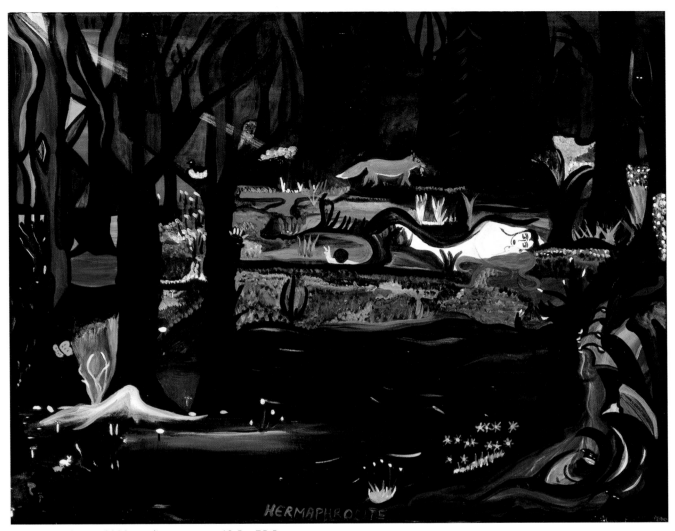

HERMAPHRODITE *2003 acrylic on canvas 60.5 x 75.5cm*

EAMON EVERALL

Lives in East London on the edge of Epping Forest. 'Frugal'. Collectors include the Crown Prince of Oman.

6.10.48	Born Aldershot, Hampshire to army family. Only child.
1953-64	Attended fourteen different schools including Germany and the Far East.
1967-72	Folkestone School of Art, Foundation Course. Waltham Forest School of Art, Diploma in Art and Design.
1972	Wimbledon School of Art, Postgraduate Certificate in Printmaking.
1973-74	Worked as deckhand and helmsman on a Rhine river boat. Postman. Dustman.
1974-76	ARCUK scholarship at the Architectural Association School of Architecture.
1976-88	Part-time art lecturer, antique fair promoter, musical instrument repairer, builder's assistant labourer.
1988-	Working week spent between own studio work and Head of Art & Design, Redbridge Institute, London.
1996	MA (Visual Theory), University of East London.
1999	Founder member of The Stuckists.
2001	Public Artwork Commission millennium sculpture.

Practices Buddhist meditation, Tai Chi and Cajun dancing. Has teenage son and young daughter. "I thought I'd done my growing up, but it wasn't 'til my father died in 1997 that I realised I had a whole lot further to go." Goes running in the forest. Visits the Southeast coast whenever possible. As a result of living in Malaya, developed a life-long taste for hot, spicy things.

The Gift: "The whole idea for the painting came to me in a flash when I was doing a meditation retreat. I don't want to talk about the image and the content, because it's a mystery, which the viewer has to solve and unravel themselves. Superficially it's a woman sitting behind a table seen through a doorway, but like life it works on a number of different levels. I'm trying to create paintings which can be revisited time and time again, so the viewer finds a growing set of meanings and sensations."

"I work from life whenever possible. I usually have the subject in front of me. Some paintings are worked on over a period of years, others a mere few months. There are many layers – if you were to X-ray the paintings, you would see a web of significant changes. It's hard work, but at times I feel elated and in a state of grace, as things come together. I regularly read books on paint chemistry, technique, history of art, composition and the perceptual process. I consider this knowledge an important part of the painter's method."

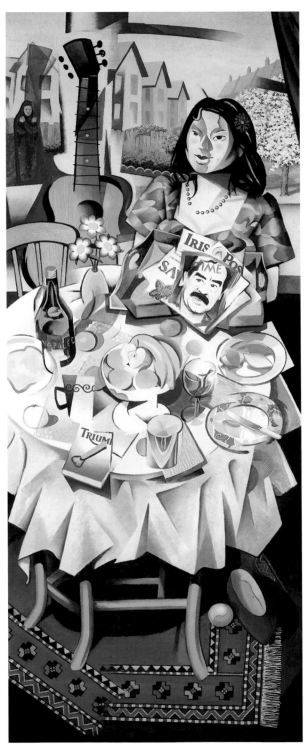

THE GIFT *2004 oil on board 195.5 x 76.3cm*

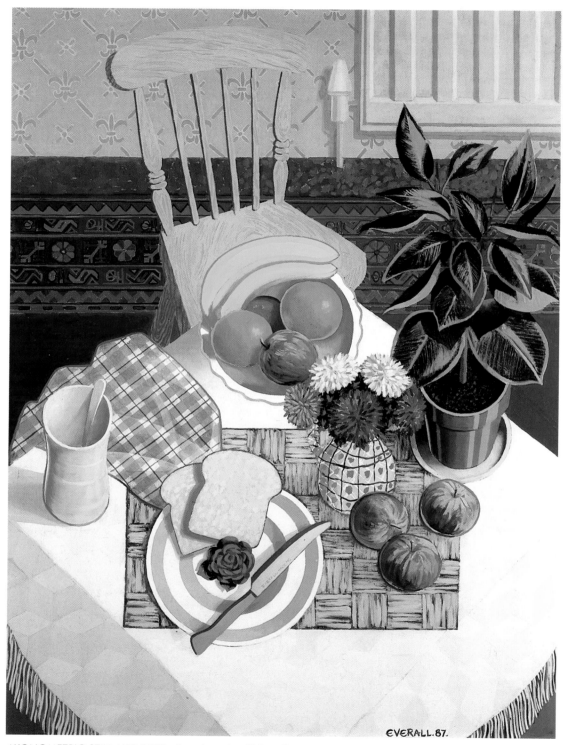

EVERALL. 87.

AXONOMETRIC STILL LIFE *1987 oil on board c.65.2 x 48cm*

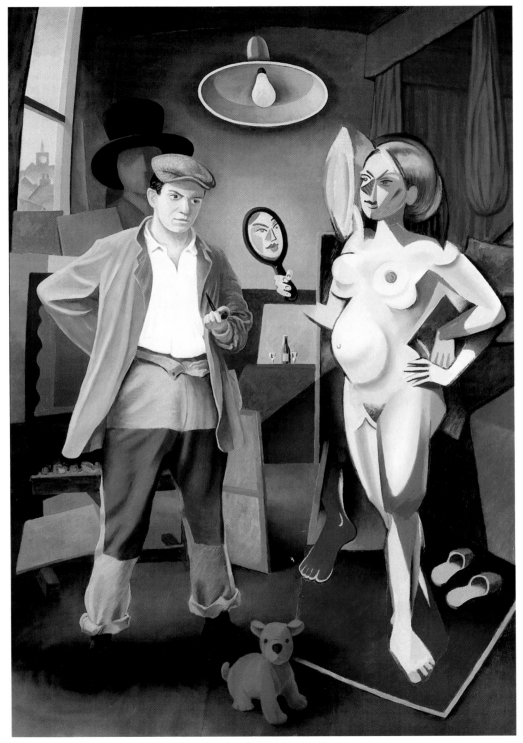

THE MARRIAGE (AFTER VAN EYCK) 2002 oil on board 91.4 x 61cm

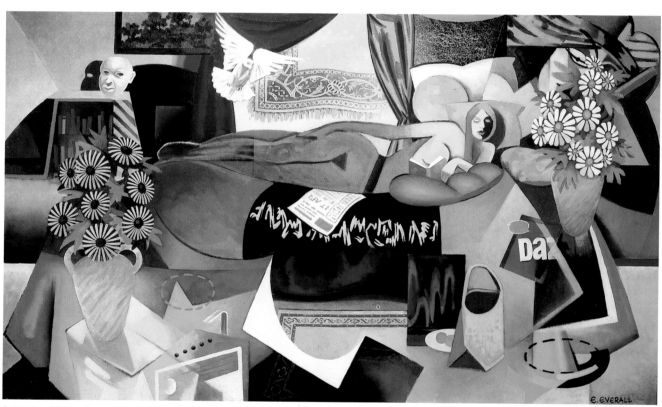

OLYMPIA *1999 oil on canvas 56 x 91.6cm*

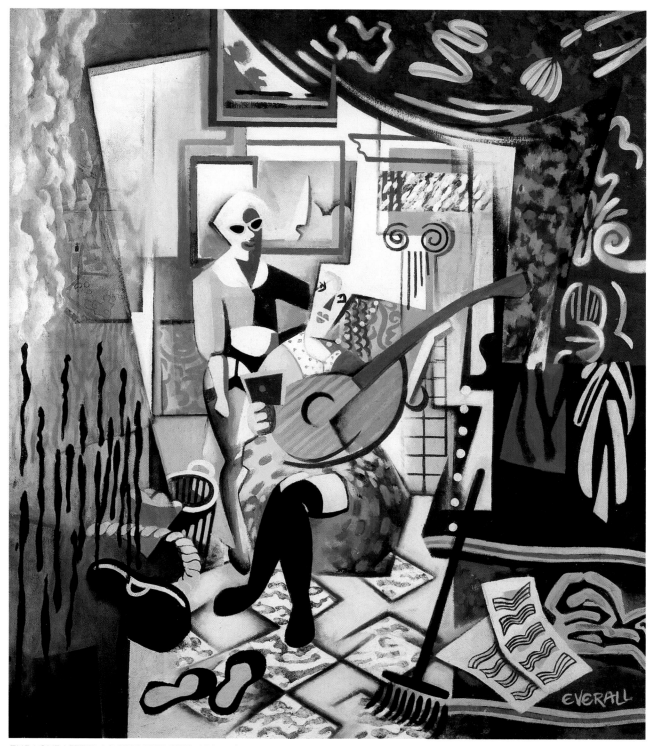

THE LOVE LETTER I (AFTER VERMEER) *1987 oil on canvas 66.4 x 56cm*

ELLA GURU

Lives in Arsenal, London, with husband Sexton Ming. Started the Stuckist web site.

24.5.66	Born, Ohio, USA.
1982-84	Fort Hayes Career Center – commercial art course.
1984-86	Columbus College of Art & Design. Left because of "all the conceptual crap."
1986-87	Took lots of LSD.
1988-89	Ohio State University, BA (Fine Arts). Allowed to paint. Visual Arts Award.
1990-91	Go-go dancer/stripper. Travel to India and Africa.
1991-92	Islington: waitress, Mexican Restaurant and Islamic lifestyle in Algerian household.
1993	Number one in Indie charts as member of *Voodoo Queens* pop band.
1996	Rode bicycle to Lithuania. Met Sexton Ming in London when she borrowed his lipstick.
1997-	Website designer. Started painting intensely again.
1999	Founder member of the Stuckists.
2001	Married fellow Stuckist Sexton Ming on Dorset cliff top in drag.
2002-3	Commissions for Von Stockhausen family. Went to Cuba.

Plays in *The Deptford Beach Babes*. Amsterdam *Gay News* 'Painter of the Year'. Used to frequent fetish clubs and spank men whom she describes as "Tory politicians". Had lunch with Quentin Crisp in New York: he thought she was weird.

The Queen's Speech: "It started off on Christmas Day in a friend's house in Pennsylvania. We have worked together over many years dressing people up and staging scenes for photographs. It was her idea in this case. When I got back to London, I did a painting based on this photograph (of Sexton), adding objects that were not originally there – they don't have absinthe in America. I did some studies of Sexton from life also. I've always liked wigs. You get obsessed with a shape and you like it – I don't know why."

"A painting can take between two days and two years. I start one by going out and getting pissed with my friends. Then the ideas will come from photos I take. They are often very bad, dark, fuzzy photos, so I have to use my imagination and real life studies later. I start from line drawing always. I like the subject to look three-dimensional. I admire Old Masters, but I don't necessarily try to paint that way. When I went to Art College we did three years of painting nude models from life. I learned a lot from doing that. I care very much about ability and technique, and I'm always working to improve it, but I also admire work which is untrained but inventive."

Web site www.ellaguru.org.uk

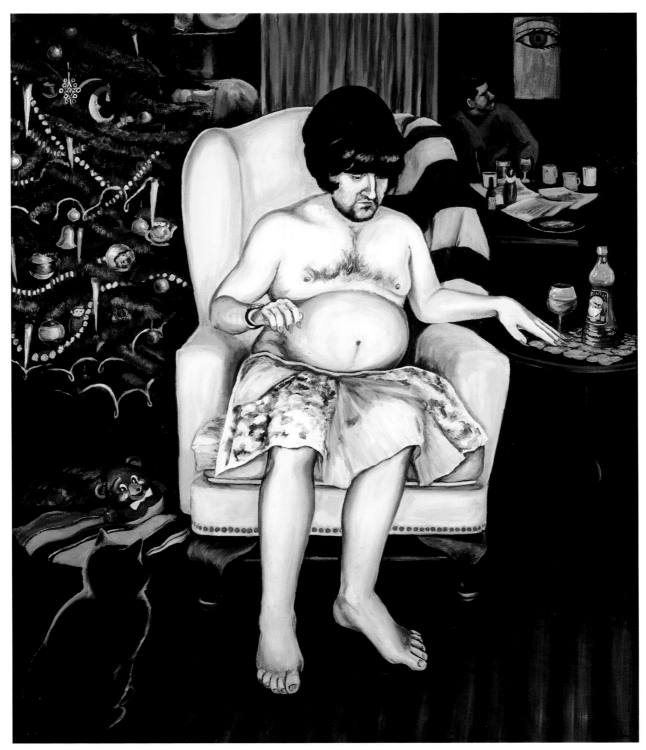

THE QUEEN'S SPEECH *2002 oil on canvas 121.8 x 101.8cm*

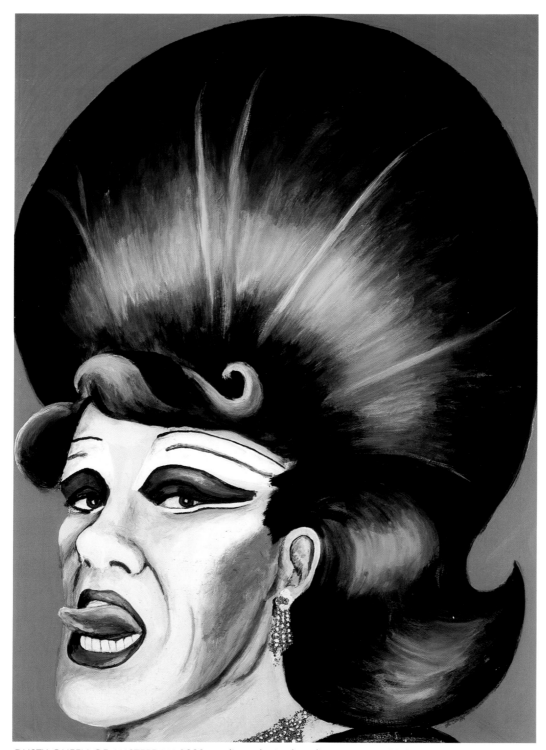

DUSTY QUEEN OF AMSTERDAM *1998 acrylic and mixed media on paper c.82.8 x 57.3cm*

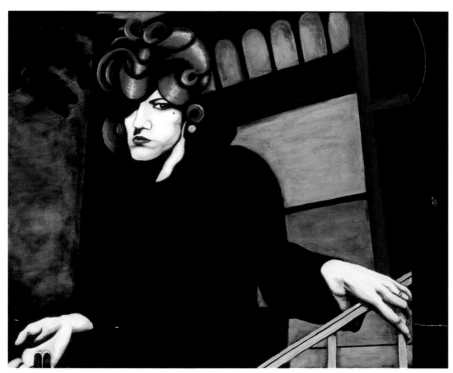

GOODBYE COLUMBUS *2002 oil on canvas 106.3 x 116.5cm*

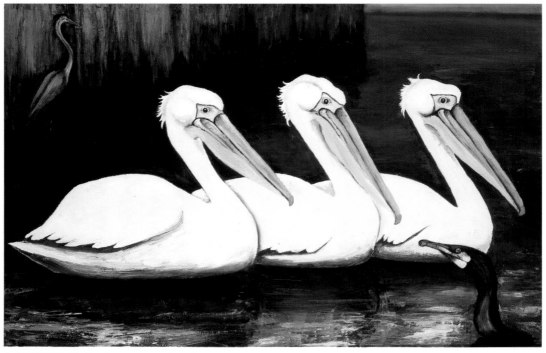

3 PELICANS *2002 oil on canvas 61 x 91.5cm*

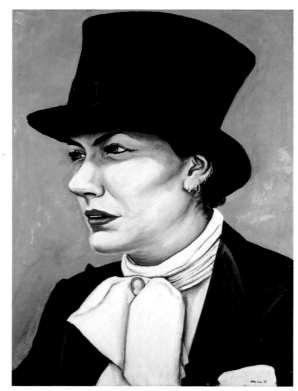

THE GROOM *2001 oil on canvas 91 x 66cm*

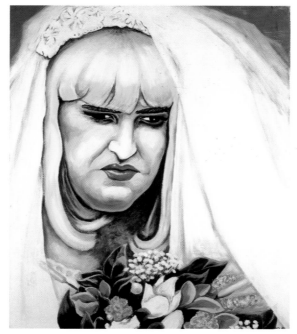

THE BRIDE *2001 oil on canvas 91.4 x 75.7cm*

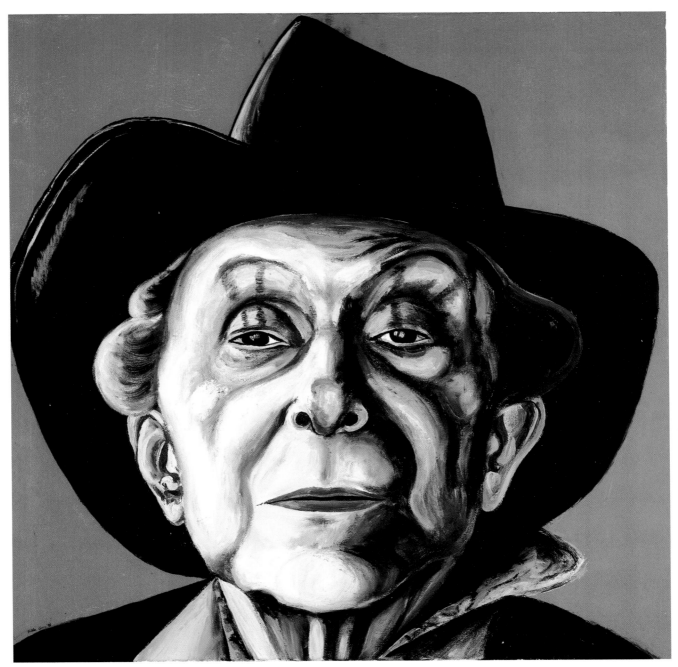

QUENTIN CRISP *2001 oil on canvas 76 x 76cm*

PAUL HARVEY
Guitarist in punk band *Penetration*, college lecturer, safe driver.

7.5.60	Born Burton-upon-Trent, Staffordshire.
1971-78	Burton Grammar School.
1978-82	North Staffordshire Polytechnic: Foundation Art, BA (Hons) Design.
1982-85	Moved to London. In post-punk bands. Worked at Our Price and Forbidden Planet.
1986-2000	Moved to Newcastle to join Pauline Murray's band. Co-published Mauretania Comics. Taught graffiti art.
2001-	Founded The Newcastle Stuckists. Full-time lecturer Art and Design, North Tyneside College.
2002	Curated *Stuck in Newcastle*, Newcastle Arts Centre. Joined *Penetration*.
2003	Started MA in Fine Art Practice, University of Northumbria.
2004	Stuckist Co-curator *Members Only: the Artist Group in Japan and Britain* with Hiroko Oshima, Ryu Art Group.

"You don't think it's tempting fate, saying 'safe driver'? I don't want to die in a horrible accident. Why don't you write 'genius whose talent hasn't been fully recognised'?" Partial to scallops and oysters, obtained by his builder from a secret location in Scotland. Drives to Hull estuary because "I like to go where there isn't anything." Obsessive timekeeper. Pessimistic England supporter. Genius whose talent hasn't been fully recognised.

The Stuckists Punk Victorian: "Originally to promote *Stuckists Real Turner Prize Show 2003* – the placard that the woman is holding said 'SEROTA NEEDS A GOOD SPANKING'. The figure was from a photo of Emily Mann taken for me by Charles Thomson. Then, a guest artist, Gina Bold, who was his girlfriend, got really angry and started a debate about the S&M/fetish allusion. She got really pissed off with me because I didn't agree with her. Then it got a bit nasty – the whole thing was just daft. Then the show got cancelled – and it had all been a complete waste of my fucking time. But the painting didn't matter: I was much more upset over the situation with Gina. Everything seemed a mess. Months later I got excited about the Walker show title and repainted the placard. The painting is like a phoenix from the ashes. It would be nice if Gina finally saw it – and liked it."

"I use photographs but change the composition on a computer. I project onto canvas, trace the masses with a blue pencil, paint the details freehand with a sable brush, and the larger areas two to four times (for opacity) with Japanese or decorator's brushes. I often change figures to get it right. I paint incessantly at home – paintings take up to three months."

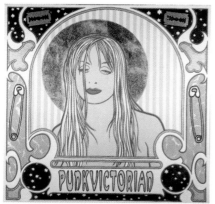

PUNK VICTORIAN
2004
acrylic and gold leaf on canvas
61 x 61cm

THE STUCKISTS PUNK VICTORIAN
2004
acrylic on canvas
212.5 x 75.5cm

TARA PALMER-TOMKINSON
2002
acrylic on canvas
182.5 x 60.5cm

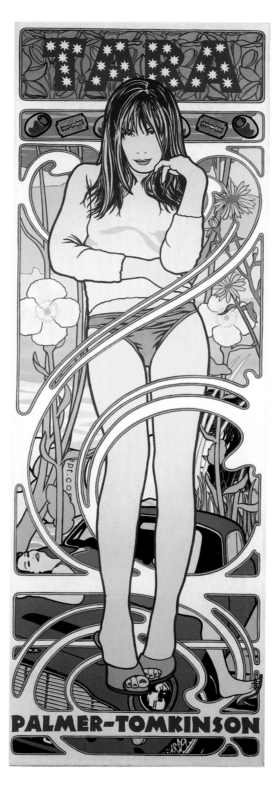

MADONNA
2002
acrylic on canvas
182.5 x 60.5cm

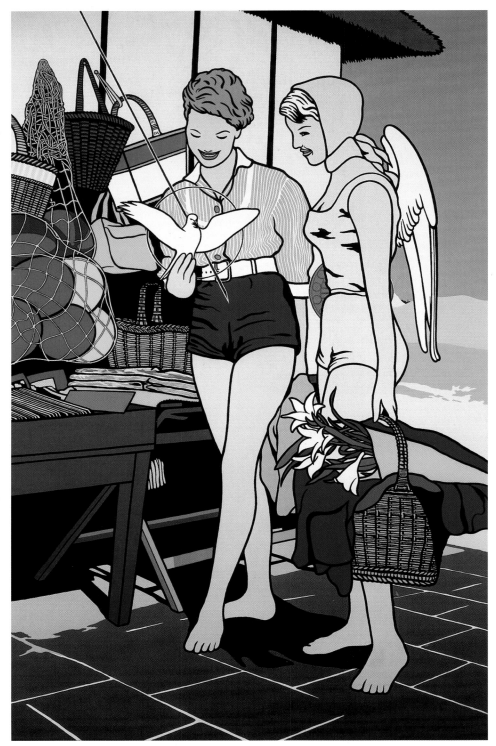

AN ANNUNCIATION *2003 acrylic and gold leaf on canvas 179 x 112cm*

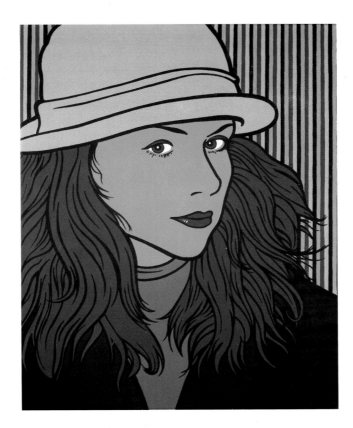

KINO VIII
2003
acrylic on canvas
50.5 x 40.3cm

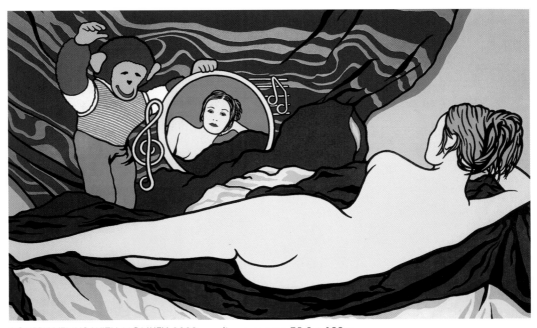

ROKEBY VENUS WITH MONKEY 2002 acrylic on canvas 75.9 x 122cm

WOLF HOWARD

Wolf Howard drums for three 60s garage bands and cycles to the shops in Chatham, where he lives.

7.4.68	Born, Strood, Kent.
1979-87	Rede Secondary School. Mid-Kent College for O-Levels (doesn't think he got any but always tells people he got two).
1986	Taught himself to play drums and has been drumming ever since for numerous bands.
1987-2002	Continuously on the dole, apart from two months sweeping the floor in an ironmongery warehouse, two months sweeping the floor in a neon light warehouse, one day apple-picking and half an hour in a frozen shepherds-pie factory.
1998	Thought about going to Art College to better himself. Decided it would worsen himself.
1999	Founder member of The Stuckists.
2000	Three-piece band (with Billy Childish) *The Buff Medways*.

"Stole Rachel Jordan away from London with the power of his impressive painting." Oxfam shop volunteer one day a week. Spends other days writing poetry, taking pinhole photographs, making Super 8 cine films and painting. Naps in the afternoon. Vegetarian. Cultivates a Victorian beard. Likes "old clocks, old lamps, old suitcases, old typewriters, old furniture."

Mrs Chippy: "People have said to me, 'What's the point in painting a cat? My five-year-old daughter could do that.' Yes, she could, but would it be a cat that had the look in its eyes that conveyed to you that it was about to be shot? That's the fate that befell Mrs Chippy during one of the greatest survival adventures ever – Ernest Shackleton's voyage to the Antarctic in 1914 on the ship *Endurance* – shown in the background of the painting, stuck in the ice, as the crew drag the small open boat which later accomplished an 850 mile rescue journey through sixty-foot waves. That's the difference between my cat and a five-year-old's. I also paint cats where there is no difference."

"I work from imagination and sketches from life. I draw on the canvas with charcoal before I paint and then try to get the whole thing finished in one go. It's frustrating to have to return to a painting many times before it feels right but I often have to. That's the most important part of growing as an artist and a person. I'll do the whole background before I can look at it and know it's wrong. Then I have to go over it or scrape it off. That can easily happen ten times on some of them."

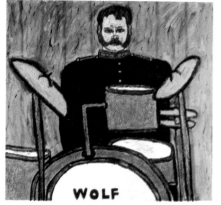

WOLF HOWARD ON DRUMS
2002
oil on canvas
112 x 112cm

MRS CHIPPY 2001 *oil on canvas 122 x 91.2cm*

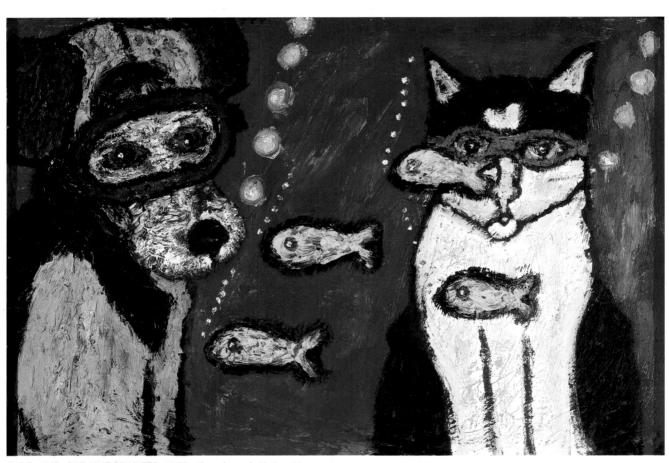

DOG AND CAT UNDERWATER *1998 oil on board 40.5 x 51cm*

DEATH BY FIRING SQUAD *1999 oil on canvas 80.1 x 99.6cm*

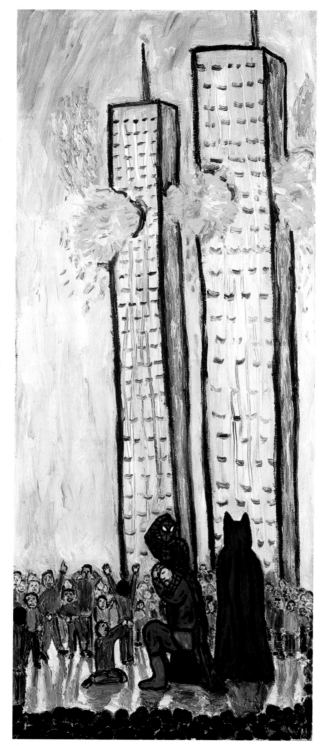

SUPERPOWERLESS *2003 oil on canvas 99.8 x 40cm*

ENDURANCE *2003 oil on canvas 127 x 101.5cm*

RUSSIAN GIRL *2004 oil on board 39.1 x 56.3cm*

BILL LEWIS

Happily married, lives in Chatham, artist, poet, story-teller and mythographer.

1.8.53	Born in Maidstone, Kent. His father was a shepherd and farm worker.
1964-68	Westborough Secondary Modern School. No qualifications.
1968-75	Unloading trucks in Pricerite's supermarket warehouse, Maidstone.
1975-76	Unloading trucks in Cheeseman department store, Maidstone.
1976	Nervous breakdown. Attempted suicide. Three months in Crossfield psychiatric ward (Oakwood Hospital), West Malling.
1977-78	Medway College of Art and Design, Foundation Art.
1979	Member and namer of The Medway Poets.
1978-82	CSSD Porter, West Kent General Hospital.
1982-	Full-time artist with forays into tomato picking, a yoghurt factory and cleaning floors in Tesco. Writer-in-Residence, Brighton Festival.
1999	Founder member of The Stuckists.
2001-	Teaching mythology course at Kent Children's University.

Six books of poems and three of short stories; five reading tours of USA and one of Nicaragua. Movie buff. Solo show at Rochester International Photography Festival. Included in World Fantasy Award winner *The Green Man* (Viking Press), Member of School for Prophets, liberation theology.

God Is an Atheist – She Doesn't Believe in Me: "I had this move through Christianity and Judaism towards something else – I'm not quite sure what yet. The woman represents both my idea of holiness and the feminine part of myself, which is my link to the Great Mystery – that otherness that you sense behind things but you don't know what it is. I used to call it God, but now that seems a very lame word. In old paintings the dog would have represented fidelity, but it could also be an anagram of God or a trickster figure who illuminates the human shadow (the buried part of us). None of these things are separate: they only appear separate. My paintings are like a magic mirror in fairy stories. I hold it up to try to see my true likeness. Sometimes it takes me years to work out what the symbols mean. That's why I do them – to try and find out something."

"I taught myself to paint. I have been influenced by Anna Maria Pacheco, Paula Rego and Marc Chagall, as well as comic books and movies. My work is not about the technique, but what's underneath it. That's not to say I want to paint bad pictures. I keep drawing or painting the image – maybe even seventy or eighty times – until it's the way I want it."

Web site www.endicott-studio.com/biolewis.html

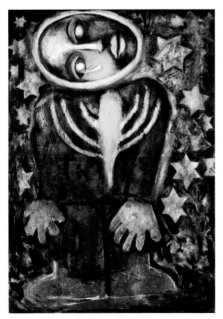

SLEEPER OF PRAGUE
2004
acrylic on canvas
91.5 x 60.6cm

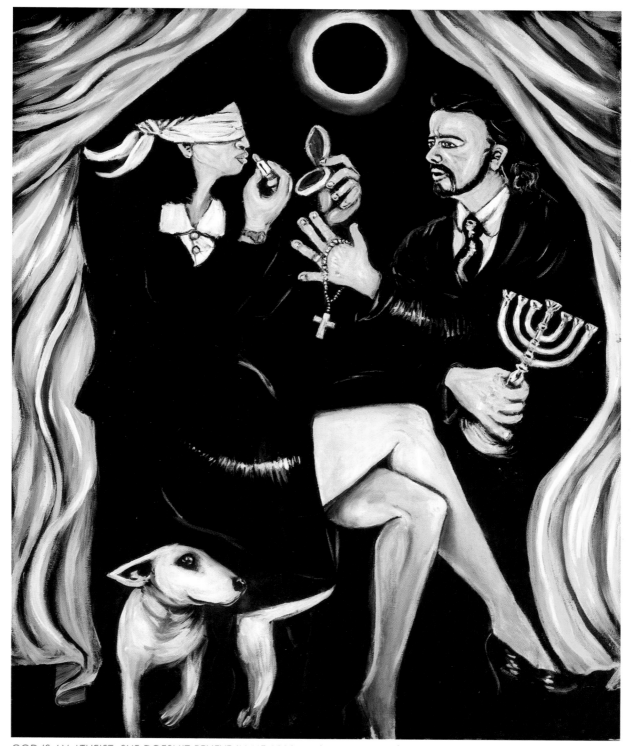

GOD IS AN ATHEIST: SHE DOESN'T BELIEVE IN ME 1999 *acrylic on canvas 99.5 x 80cm*

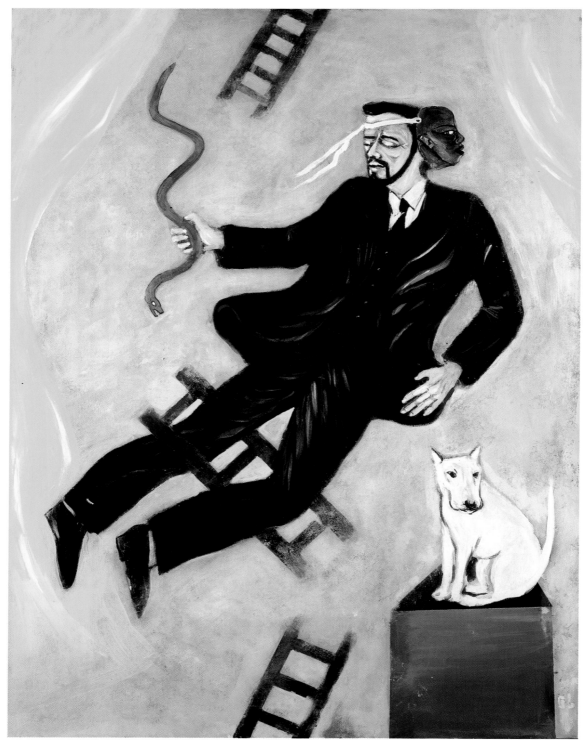

THE LAUGHTER OF SMALL WHITE DOGS *2000 acrylic on canvas 101.3 x 76cm*

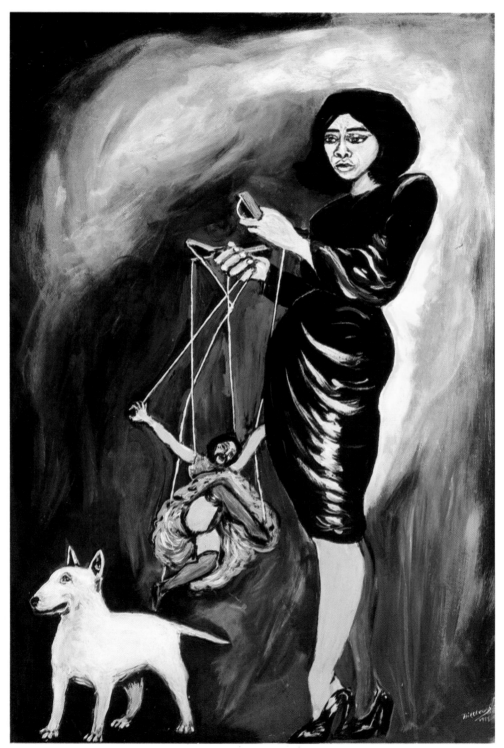

ME X 3 1999 acrylic on board 76 x 50.5cm

JOE MACHINE

Trying to escape from the Isle of Sheppey and living on his wits. Used to rob pubs.

6.4.73	Born, Chatham, Kent.
1982-88	Thomas Cheyne Middle School. Fulston Manor Secondary School, Sheerness.
1988	Alston House Approved School, Rochester (theft of scrap).
1989	Dover Borstal (burglary from Leysdown Greengrocers).
1990-93	On the dole in Chiswick, living in a menagerie.
1993-	Managing family amusement arcade (Leysdown, Kent), bouncer South London nightclubs, scrap dealing, breeding and selling Rottweilers, running a cattery.
1998-	Attending psychotherapy to address problems with violence and sex.
1999	Founder member of The Stuckists.
2003	Married Charlotte Gavin (exhibitor, Stuckists *Real Turner Prize Show 2000*).

No formal art training. Influenced by Genet, Celine and Knut Hamsun. Seven books of poetry. Was the singer in `junk` group *The Dirty Numbers*. Member of Romany family. Aged six, he stabbed his teacher with a blackboard compass because she wouldn't let him draw the Incredible Hulk. Aged eight, he fell in love with Diana Dors after she waved out of a Ritz hotel window at him. "The violence and the stealing and the aggressive manipulation in sex – these things have been done because actually I'm quite a frightened little fucker inside – it's a byproduct of my vulnerability."

My Grandfather Will Fight You: "My grandfather was a Romany boxer, but sometimes fought bare-knuckle, which his own father did for a living. I loved my grandfather, although I was aware that other people were frightened of him. He always treated me with a great deal of love. It's left me between two worlds – love and violence. It was definitely an emotive painting: I felt he was looking at me. In some ways he wouldn't have been very happy about it, because he was a very private man. What I study more than anything else is the human shadow. The need to paint something until you've shown as much of it as you can."

"I paint in a lean-to garage. I usually paint from sketches – mainly from life. I paint people I know or knew – it's heavily autobiographical. I use about five colours and mix them. Paintings are finished in a day or two. I've smashed up about half a dozen with pure anger at not being able to get what I want. Painting and writing have been far better for me than any of the mistakes I made in stealing and fighting."

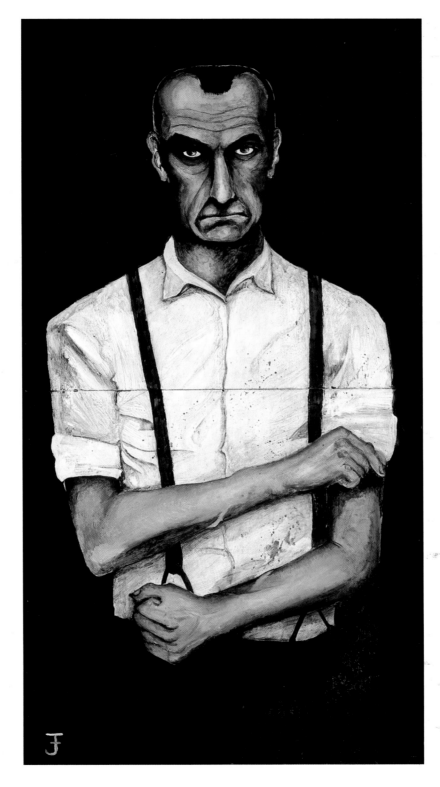

MY GRANDFATHER
WILL FIGHT YOU
2001
acrylic on board
113 x 57cm

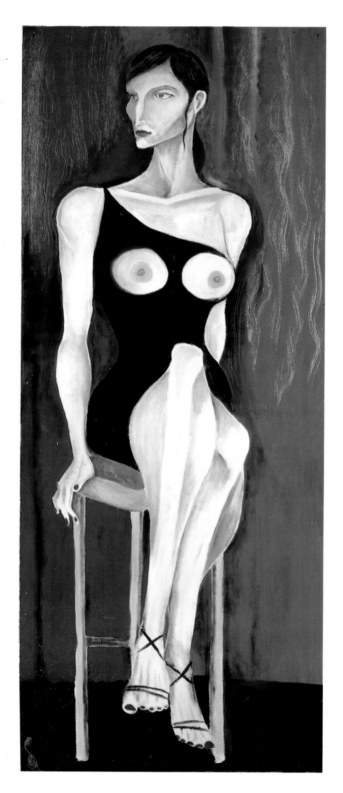

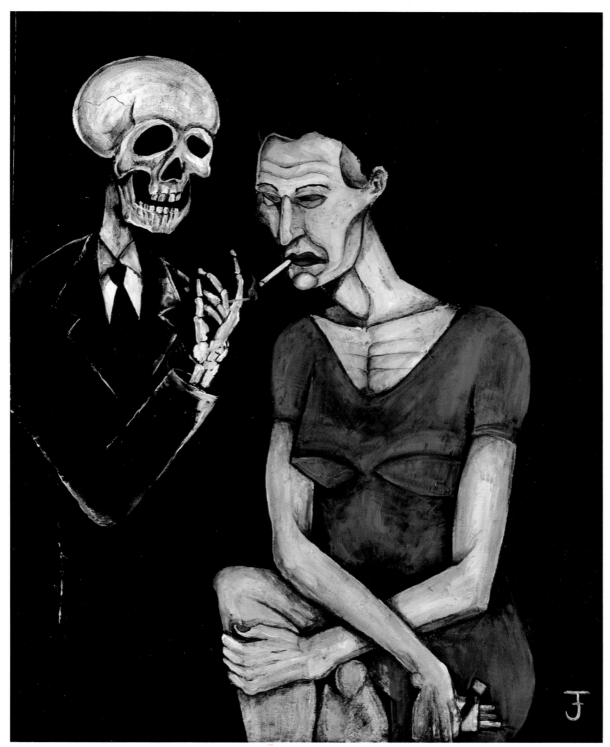

MY MOTHER'S LAST CIGARETTE *2001 acrylic on canvas 100 x 80cm*

UNTIL THE LAST DOG IS HUNG 2001 *acrylic on canvas 80 x 100cm*

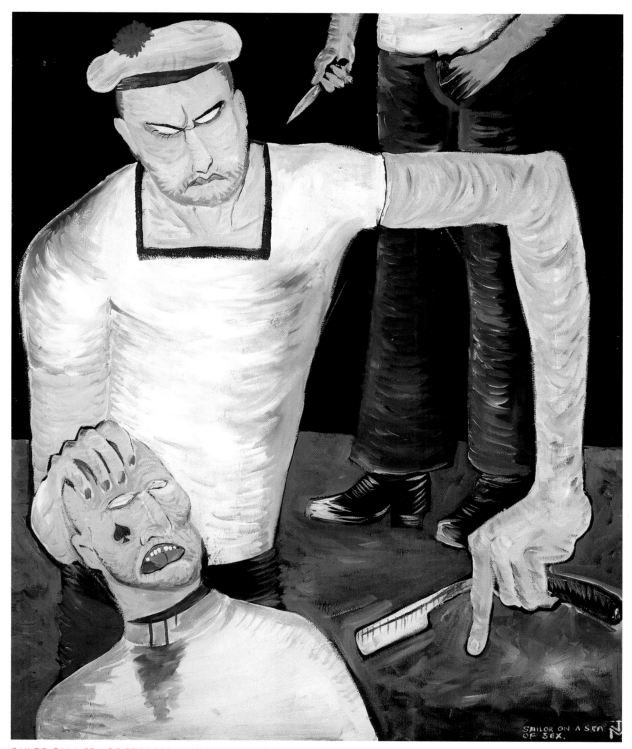

SAILOR ON A SEA OF SEX 1999 *acrylic on canvas 99.7 x 80cm*

PETER McARDLE

Lives in a Georgian farmhouse in rural Northumberland with a wife and two sons. Paints seven days a week, starting as early as 4am.

17.12.65	Born Tynemouth, Tyne and Wear.
1970-83	St Aidan's RC School, Tyneside.
1983-	Started selling paintings and has supported himself by them ever since.
1983-85	Bath Lane Foundation Course, Newcastle Upon Tyne.
1983-89	Gallery assistant and then ran own Gallery 2.
1989-92	Sunderland University BA Hons and "my arse well and truly kicked for being a figurative painter".
1990-	Started exhibiting in commercial galleries.
1992-	Solo shows biennially – mostly sold out.
2001	Started exhibiting with Mark Jason Fine Art, Bond Street.
2003	Founded The Gateshead Stuckists as "a response to the Baltic's nihilism".

Peter McArdle has chosen to distance himself from the city "as a kind of sabbatical" in order to focus on painting. There are cows and sheep outside the kitchen window – because of which he ended up in casualty with Campylobacter. His studio is on the third floor of the farmhouse.

On a Theme of Annunciation: "It's probably a lot to do with being brought up as a Roman Catholic, and a transitional moment in my life. Every Saturday night I went to confession. One day my father asked the priest to tell him his own sins. The priest clammed up and my father walked out of confession. After that we left the church. Years later I went to Venice for a few weeks and I was confronted by all this religious imagery which brought back all the guilt. I was inspired by a Titian painting with a sexual element and also wanted to paint a contemporary Annunciation. These things fused. It gets a bit more complex after that. The gun is symbolic of penetration yet also of protection. I expect the viewer to work hard. You need a certain understanding of history."

"I always paint with oil on canvas, which I prime and sand several times with gesso for a smooth surface. I sketch out in pencil and use a 000 (cat's whisker) sable brush to refine and define the sketch. Then I underpaint with burnt umber and glaze on top of that several weeks later – up to seventeen glazes. Paintings take six to nine months as an average. Usually a painting changes drastically in the last three or four months. Finally I reject around a third of the paintings."

ON A THEME OF ANNUNCIATION *2003 oil on canvas 101.3 x 101cm*

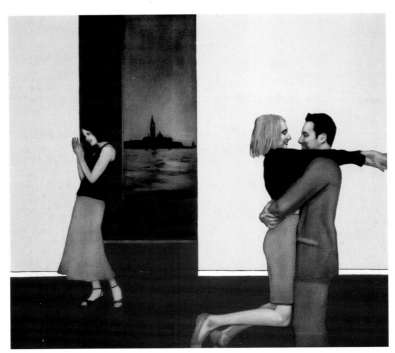

REUNION *2003 oil on canvas 101.5 x 111.5cm*

THE FORGER
2003
oil on canvas
122 x 61cm

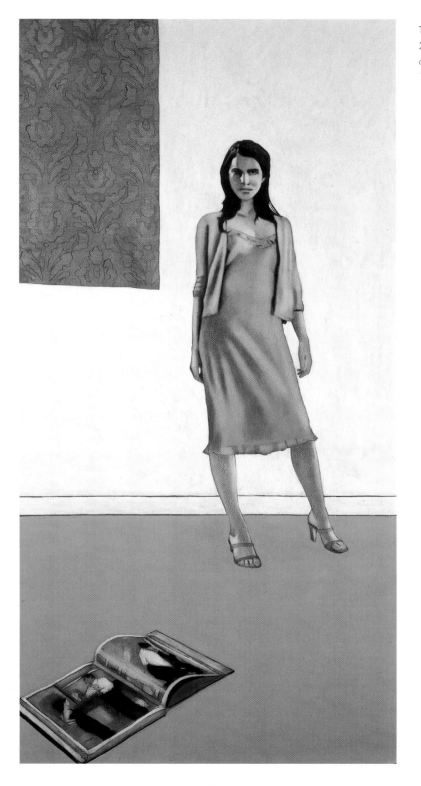

THE ACCUSATION
2003
oil on canvas
122 x 61cm

SEXTON MING

Lives with his wife Ella Guru next to Arsenal football stadium and doesn't like football.

17.9.61	Born, Gravesend, Kent.
1973-77	Southfields Secondary Modern School, Gravesend.
1978	Worked in Halfords for a month.
1979	Worked for Southern Music for a month.
1979-89	Worked for brother's record import company for £5 per week. Member of the Medway Poets.
1989-93	Lived in brother's house in Mayyene, France.
1993-96	Worked in meat factory for three weeks. Moved to Shoreditch, London. Unemployed.
1996	Whittington Psychiatric Hospital for a month. Since then registered mentally disabled (and proud of it).
1999	Founder member of The Stuckists. Started own record label, *Rim Records*.
2001	Married fellow Stuckist Ella Guru on Dorset cliff top in drag.
2004	Buying own flat in Arsenal.

Eighteen albums. Occasional poetry and music tours USA, Europe. Short story writer for Berlin *Junge Welt* newspaper. Two leading roles (one as Queen Victoria) in the film *Pervirella*. Likes Guinness, but hasn't drunk it for a while. Doesn't like "people shitting on their own doorstep." Captain Beefheart fan.

Leigh Bowery: "I thought I would get the contortions that Leigh Bowery did with his body in performances – which I don't think Lucian Freud captured. I was on the same bill as Leigh a couple of times with my band *Sexton Ming and the Diamond Gussets*. He used to dye his pubes green or whatever colour he liked. That was his trait to look as freakish as possible. He invented fashion victims. He was a very intelligent guy, very sharp witted. He had a lot of guts."

"I get the ideas from observation of the world around me. Then it gets put into a liquidiser and something else comes out. Everyone's got their own personal liquidiser. I doodle and it's like a subconsciousness thing. I usually tone the colour. One method is to take a colour and not just mix it with white but a flesh tint as well. If I want to do a red, I might mix up a bluey grey with white and mix that into the red. It's one of these things that's developed over the years. I can see in my mind's eye what colour is going to go with what colour. I think about it for quite a while. I can do two paintings a day but I don't, because quite often the second painting doesn't have the feeling in it."

Web site www.sextonming.co.uk

LEIGH BOWERY
2004
acrylic on canvas
45.7 x 35.5cm each

PRESIDENT *2004 acrylic on canvas 45.8 x 35.5cm*

DOUBLE JOINTED MEN *2004 acrylic on canvas 45.8 x 35.5cm*

PEOPLE WALKING WITH NO ARMS 2004 acrylic on canvas 51 x 61cm

TOILET MONSTERS PLAYING HOSE PIPES 2001 *acrylic on canvas 35.5 x 45.7cm*

CHARLES THOMSON

Moved from a house in Finchley by a stream to Shoreditch and back. Ex-wives include Stella Vine.

1953	Born, Romford, Essex.
1964-70	Brentwood School, Essex in same class as Douglas 'Hitchhiker' Adams.
1969	Founded Havering Arts Lab for Performance Art ("Sex Orgy Tale – Group Banned", Havering Express).
1971	Stood for Havering Council as Dwarf Candidate (22 votes).
1970-72	'Betterware' door to door brush salesman. Self-employed 'underground' magazine distributor (including Schoolkids OZ).
1973-79	Thurrock Technical College, Foundation Art. Maidstone College of Art, FFIAD (First Fail in a Decade).
1979	Member of The Medway Poets.
1979-87	Part-time telephonist/receptionist, Kent County Ophthalmic and Aural Hospital.
1987-99	Full-time poet. 2000 poems and work in 100 anthologies. Performed in 700 schools.
1999-	Full-time artist (resumed painting in 1997 after fifteen-year abstinence).
1999	Conceived of, then co-founded The Stuckists with Billy Childish.
2001	Stood in the General Election. Second marriage, in New York to Stella Vine, lasted two months.
2002-04	Director Stuckism International Gallery, Shoreditch.

Spent most of the last five years promoting Stuckism, organising anti-Turner Prize clown protests and being accosted by Sir Nicholas Serota in Trafalgar Square. Has studied Kabbalah and astrology for thirty years. Practices past life therapy. National poetry prizewinner. First commercial artwork at the age of five – sold a drawing of his teddy bear to granddad for a penny. Arrested in 1972 for protesting against pollution in Oxford Street. Has a son fanatical about motor racing.

I Feel Bad When I Reject Your Love: "Based on something a (now ex) girlfriend said to me. I thought it was a negative picture, but then I realised it was positive because it's a reconciliation after self-knowledge. It's also ambiguous as to who's speaking. Most of my paintings are based on experiences with people I know, usually on a drawing from life, but in this case from a photo I took of her. She can't really complain because she exhibits nude paintings of me."

"I do line drawings spontaneously and uncorrected with a black wax crayon in a sketchbook. Then I choose one, blow it up on the canvas and paint the black line in acrylic. The colour is oil paint (Old Holland) and nearly always remains the first colour I paint in – though it can take an hour to mix it. I feel what the colour should be. The final image is a synthesis of material, emotional and spiritual experience."

I FEEL BAD WHEN I REJECT YOUR LOVE *2004 oil and acrylic on canvas 76.2 x 101.6cm*

RED GUITAR *2001 oil and acrylic on canvas 91.4 x 121.9cm*

THASSOS HARBOUR AT NIGHT *2003 oil and acrylic on canvas 91.5 x 122cm*

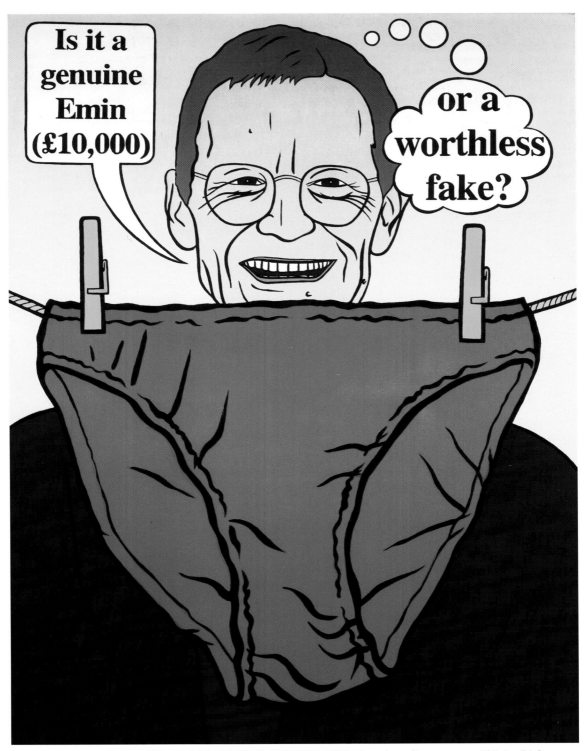

SIR NICHOLAS SEROTA MAKES AN ACQUISITIONS DECISION *2000 oil and acrylic on canvas 101.6 x 76.2cm*

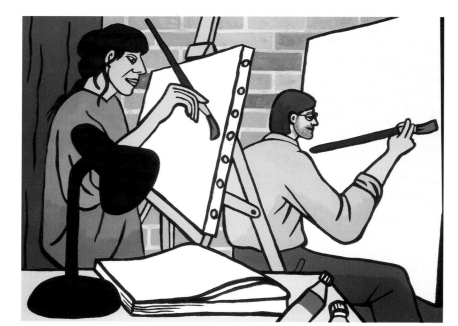

GINA LEARNS TO
PAINT AT STUCKISM
INTERNATIONAL
2004
oil and acrylic
on canvas
91.4 x 121.9cm

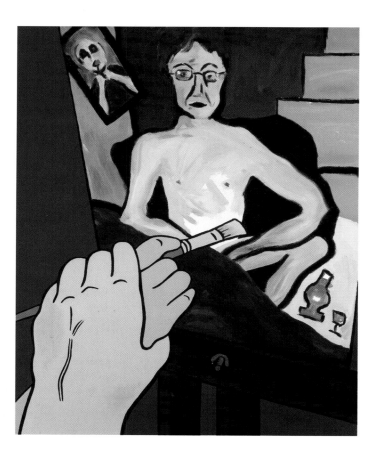

GINA'S FIRST PAINTING
2004
oil and acrylic on canvas
41 x 30.5cm

SALVATOR ROSA (AFTER
SALVATOR ROSA)
2004
oil and acrylic on canvas
101.6 x 76.2cm

WOMAN IN DYLAN CAP
WITH CIGARETTE
2003
oil and acrylic on canvas
76.2 x 101.6cm

CHARLES WILLIAMS

Recently moved from Faversham to East London and paints 'professionally' 9-5.

16.3.65	Born, Evanston, Illinois.
1976-82	Kent College, Canterbury.
1982-84	Dropped out, signed on and smoked dope in Canterbury.
1984-85	Canterbury Technical College, Pre-Foundation Course.
1985-89	Maidstone College of Art: Foundation Art and BA (Hons) Fine Art – Painting.
1989-92	Royal Academy Schools, Diploma in Painting. Awarded The Silver Medal for Painting (top student) and The Prize for Anatomical Drawing.
1992-97	Part-time cab driver, art lecturer/artist.
1996	Elected to NEAC (New English Art Club). Now on the committee.
1997-	Full-time artist
1999	Founder member of The Stuckists.
2001-	Represented by The Sheen Gallery.
2004-05	One man show at Bakersfield Museum, California.

Regular exhibitor at the Royal Academy Summer Show, Mercury Gallery. Royal Overseas League Travel Scholarship. The Richard Ford Award for Study in Spain. Collections include Alan Howarth MP and Lily Savage. Enjoys cooking pasta. Eats a lot. Favourite food: pasta. Put on weight (because of pasta). "My RA training has been invaluable, but I always feel uncomfortable when people with my training laugh at those who haven't but are still creative and sincere. I value their paintings."

Large and Pleasant Living Room: "My tag for this series of paintings is 'Big Brother meets Vuillard'. Like all my paintings, this is an invented space peopled with invented characters – they seem to sort of come to me, and when I've finished painting them, I realise they have some sort of relationship with real characters and events. Essentially it's all to do with tensions and hidden autobiographical details."

"I paint in the easiest way I can – in oils on canvas. I work on different canvases in different states and rotate them. Generally they are worked from generalised almost abstract forms into more particular definitions. Often the subject comes out of the instinctive composition. Many years of training have now given me a repertoire that enables me to create in the same way, but directly from my imagination. I've copied the Old Masters in the past and learnt from them, which now allows me to invent my own means."

Web sites www.charleswilliams.co.uk
www.chazpix.com
www.newenglishartclub.co.uk

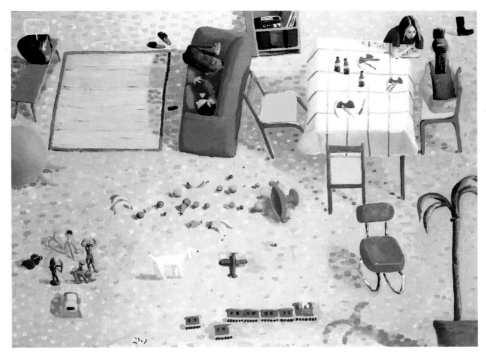

LARGE AND PLEASANT LIVING ROOM *2004 oil on canvas 87.5 x 117cm*

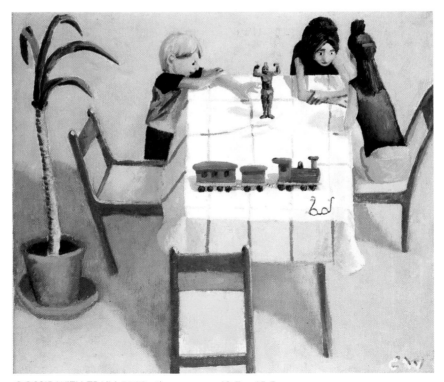

GOSSIP WITH TRAIN *2003 oil on canvas 40.7 x 45.7cm*

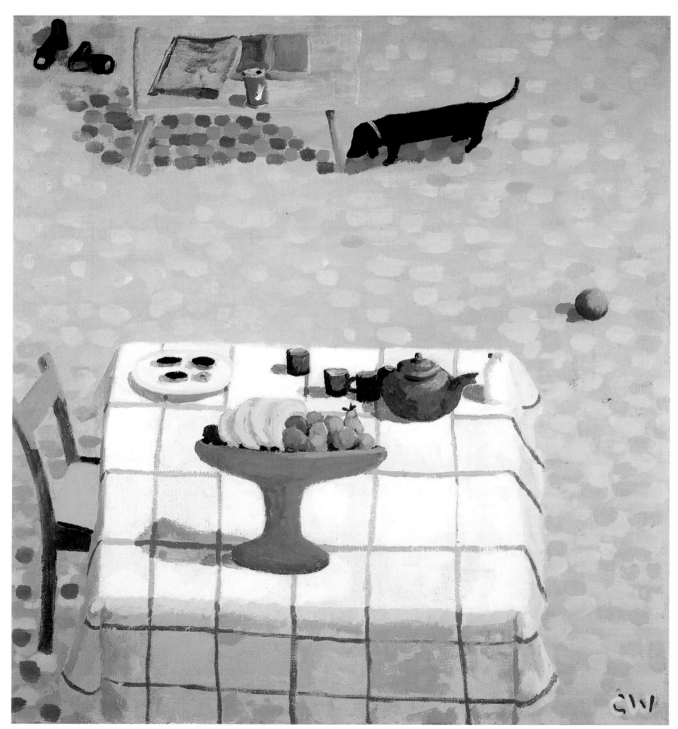

DACHSHUND STILL LIFE *2002 oil on canvas 45 x 40.5cm*

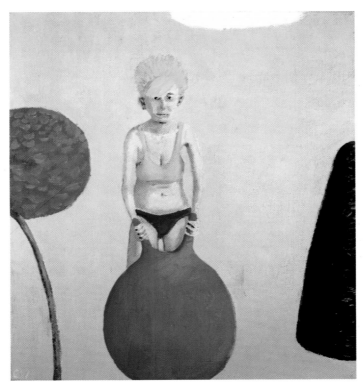

HOPPER WITH RED PANTS 2002 oil on canvas 45.5 x 40.5cm

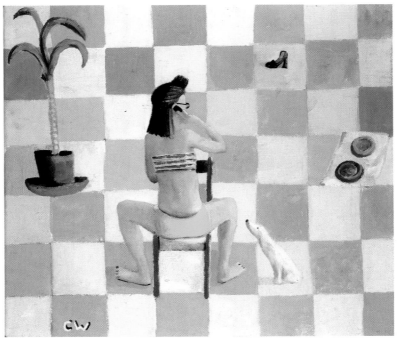

EMPTY BOWLS 2003 oil on canvas 40.7 x 45.7cm

0100481886

MANDY McCARTIN

Aggressive, tender, romantic, butch working class lesbian, soul freak, moving from East End to Highbury.

10.4.58	Born Sheffield.
1969-74	Myers Grove Comprehensive School, Sheffield.
1974-6	Worked in shoe shop and library.
1976-81	Chesterfield Art College, Foundation Art. North East London Polytechnic, BA (Fine Art).
1981-	Worked on several mural teams, including Operation Clean-up Islington and Newham Community Murals, intermittently on the dole, van driving, care work for disabled sex writer and actor Penny Pepper, play scheme art teacher (spray paint murals), Columbia Road garden centre (nasty head cut from falling watering can).
1996	Monograph *From the Street* (éditions Aubrey Walter).

Group shows include Whitechapel Open, New Contemporaries, William Jackson Gallery (Cork Street); solo shows at Battersea Arts Centre, Gallery 108. Soul DJ on gay Northern Soul Revival scene. "I was a bit of a womaniser really. Now I've got a 21 year old gorgeous girlfriend." Used to drive round in a maroon Mitsubishi Turbo-charged Sapporo. Currently upset by demise of (nearly blind) beloved sixteen-year-old cat Bebop. Collections include the Museum of London.

Tube Girls: "I was on the Central Line watching these two loud girls with incredible clothes and jewellery – you'd say 'bling' nowadays. I just wanted to paint them for that. They fascinated me. Most of my paintings are from direct life experiences. It's my way of trying to make sense of this mad world. But it doesn't work – I'm still full of stress, so I'm doing different things now – urban nature stuff (my attempt to put more beauty into it). I like the combination of the tender and the dark."

"I see something and it gets burnt onto the back of my brain usually. I don't take notes. I don't do much preliminary work, if any. I'll just dive straight in and start making marks on the canvas with paint and charcoal. I can spend two or three months or more doing a big dense canvas. In the eighties I started using spray can graffiti paint as well as oil paint, because I liked the look of it and I identified with it because I am a working class artist."

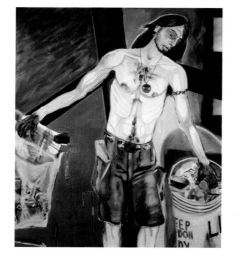

MILLENNIUM
oil on canvas
1999
183 x 153cm

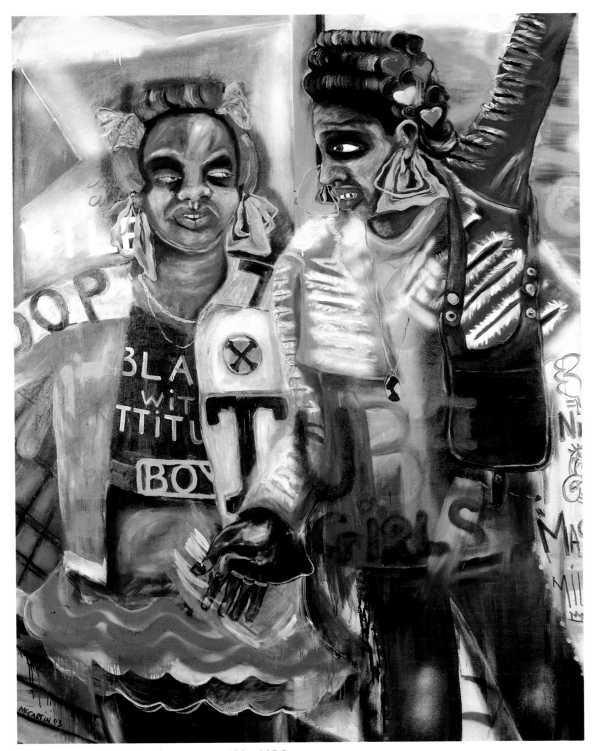

TUBE GIRLS *1993 mixed media on canvas 183 x 137.3cm*

JOHN BOURNE

Left teaching for art, lives in a red brick terraced house in rural Wales, loves motorways and supermarkets.

27.7.43	Born Stoke on Trent, Staffordshire, much of childhood in Northern Ireland.
1955-64	Llanrwst Grammar School, North Wales. Shrewsbury Technical College.
1964-68	University College of North Wales, Bangor, BSc (Physics).
1968-71	Imperial College of Science and Technology and H.C.Oersted Institute, Copenhagen, MPhil (Research on Solid State Theory).
1971-72	Computer programmer, engineering draughtsman Conway Valley Water Board.
1972-78	Maths teacher Ysgol Dyffryn Conwy (secondary school), Llanrwst, North Wales.
1978-86	Physics lecturer, North East Wales Institute of Higher Education, Wrexham.
1986	"I Did a Gauguin but not in the South Seas. I walked out. It was tremendous." Full-time artist ever since.
1990	First Prize, Mostyn Open 1.
2001	Founded the Wrexham Stuckists.
2003	Started Stuckism International Centre, Wales.

Grateful to his wife Joyce for her unflinching support. Plays chess obsessively. Two daughters living in the Barbican and Shepherds Bush – "I love visiting them there." Goes jogging in the hills round Caergwrle Castle. Paints in the loft. Practises a combination of self-taught Zen Buddhism and informal Christianity. His father was a Methodist minister in the Yorkshire Dales and crazy about Van Gogh. "My earliest memory was of my father copying a Van Gogh painting. (I was three)." Bach and Dostoyevsky fan.

Aeroplane: "It reflects my fear of low-flying aircraft. (I once had a nightmare of huge space fleets in the sky.) I looked out of my backdoor and saw a huge aeroplane coming straight at me over the treetops. I felt a mixture of fear and magnetic fascination. It seemed to just clear the rooftop of my house. In the painting I obsessively adjusted the angles to get it just right. I think it was a vintage Lancaster bomber they were taking for a spin."

"I start with memories. You only remember what's relevant. I make loads of sketches from imagination. I pin the sketches on the wall. I often look at a sketch for months or even years before I see a way to make it into a painting. It usually goes well at first but then I run into problems of composition. I have to make many changes. Sometimes it's years later that I find a way to finish it. I'm trying to reveal something of a world beyond time and space."

Web site: www.stuckismwales.co.uk

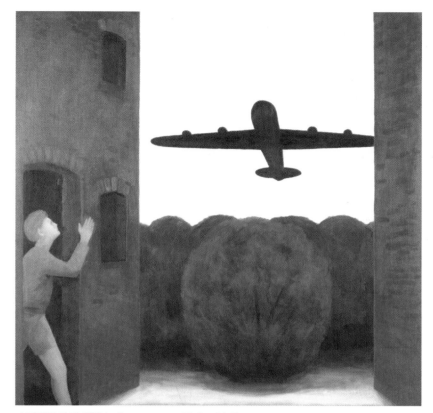

AEROPLANE 2004 oil on canvas 91.5 x 91.5cm

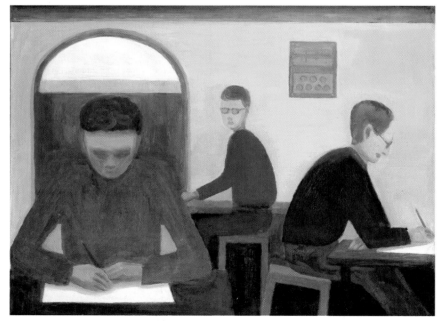

SEMINARY 2003 oil on board 36 x 46cm

DAVID JOHN BEESLEY

Lives in trendy Hackney, works as a security guard at the Tower of London. Has a shaven head.

18.4.78	Born Barking, Essex, brought up in Hornchurch but spiritually Romford.
1989-98	Brittons Secondary Modern School, then Havering Sixth Form College (for four years).
1990-	Continuously in work firstly as a paper boy, bar work, security guard, chef, set painter.
1992-2003	Age 14 started drinking heavily and continued till sobering up after University.
1998-2003	Havering FE College, then University of Reading, BA (Hons) Fine Art.
2003	Founded Romford Stuckists. One man mini-show at Stuckism International *The Vagina Monologues of an Essex Boy*, then subsequent shows.

David John Beesley is "living the dream – sort of. I'm happy working and making work." Lives round the corner from the fashionable Transition Gallery, where Charles Saatchi buys paintings of Princess Diana. Frequently meanders through the City mentally recreating its history. Novice yoga and meditation practitioner. Plays chess whenever he can. Jogs round Victoria Park, Bethnal Green.

Estate: "It's about judging books by their cover. It's quite ambiguous because you don't know who's in the right and who's in the wrong. It's about how people are crammed into these big tower blocks and you can't really escape. It's not a personal experience, but I can imagine it. My mate works for the council and has to deal with a lot of difficult issues like drug abuse, bullying between tenants and incest."

"I plan out the initial drawing of the figures in a sketchbook freehand from photos in a newspaper or ones I take myself. I project the drawing onto the canvas. At college I worked on canvases up to 10', but now I prefer easel size – and I haven't got the space anyway. I use watercolour brushes for the black lines; they get to a point where they seem to be falling apart and then they're quite good."

ESTATE *2004 acrylic on canvas 60.2 x 91.5cm*

DAN BELTON

Lives in Brighton, gets sick of friends insisting on seeing the sea, works in a library, fronts three bands.

15.9.67	Born Redhill, Surrey.
1980-85	de Stafford School, Caterham, Surrey; Warlingham Sixth Form College.
1985-89	Lugging lawnmowers and manure about in Robert Dyas warehouse, Croydon.
1989-	Croydon library, then Library Supervisor for the housebound service, Worthing Library.
1992-93	Travelled India, Nepal, Australia (split up with girlfriend), stayed with uncle in Singapore.
2000	Exhibited with Stuckists in *The Real Turner Prize Show*, Pure Gallery, Hoxton.
2001-	Founded The Brighton Stuckists; curated *The Stuckists* and *Stuck in Worthing* shows in Worthing Library.

Started to write lyrics and poems in 1985 to cope with being in a warehouse, "because it's bloody nuts in there." Book of poems *Self Hate in a Phone Free Heaven* (Hangman 1992). Has seen Withnail and I "about a million times and can sadly quote it". Writes for and performs in kraut rock, blues and punk bands.

Wapses' Lodge Sewer: "When I was a kid I had really bad asthma and had to spend most of my school summers alone in the playground playing in a sewer pipe. If I went on the field I would have got the jungle treatment – that's when they shove loads of grass and hay in your face. The painting exorcised a memory. Anything you paint or write about helps you to understand yourself more."

"I've got a very rough and ready, hands-on approach about painting. If I see a bit of wood that's the right size, I'll just grab it and paint on it – usually in skips, on the street or old fruit crates from the greengrocer's. I don't size them. I use the paints I can afford. I do one charcoal quick outline and then usually get a bottle of wine and go for it in a couple of hours, though I am slowing down nowadays."

WAPSES' LODGE SEWER *2002 oil on board 87.5 x 87.5cm*

S.P. HOWARTH

Lives in Balham and is desperate to get out of London. Wants to get to Parnassus. Works in a video shop. Obsessed with sex and violence. Is not violent, but is severely dyslexic.

23.7.81	Born Lewisham, London.
1994-2000	St Christopher's School, Letchworth, Hertfordshire ('progressive' school).
2000-02	Camberwell College of Arts – failed all assessments and left in disgust.
2002-2003	Assistant Rivington Gallery, sold double glazing door to door (for two days), building work (part of the BT tower), gardening, paper round, bar work, factory making DVDs, market research.
2001	Exhibited in *Vote Stuckist* and subsequent shows, Stuckist Party election helper, Stuckist anti-Turner Prize demos.
2002	*I Don't Want a Painting Degree, if It Means Not Painting* solo show at Stuckism International.
2003	Accused in *Time Out* by Sarah Kent of painting soft-core pornography. Indignant letter published from S.P. stating it was quite obviously hard-core.
2004	Founded Balham Stuckists. Joint winner UK Poetry Idol 'Short Fuse' competition

TEMPTATIONS OF A POET *2003 acrylic on board 33 x 31.8cm*

S.P. (Steven) Howarth's conflict with Camberwell Art College became national news with a story in *The Times* titled, "Students accuse art college of failing to teach them the basics". S.P. comments, "I was told my paintings didn't count as work, because Camberwell was an 'ideas-based' college. I said my idea was to paint what I felt. I was told this didn't count as an idea."

Temptations of a Poet: "It's a self-portrait. It's a painting about a certain atmosphere in a part of town that offers both dangers and pleasures. It's based on experiences of walking through areas of London late at night. It's the job of the artist to document things and to have a range of experiences and environments. I often paint urban and suburban nightscapes, because that's a time when all the freaks come out."

"I often paint on scrap wood chucked out on the street. *The Absinthe Drinker* was painted on a small table top. Most paintings are done in the course of a single night in one sitting, mixing directly on the painting surface. It pisses me off – the paint drying on the palette."

DANIEL PINCHAM-PHIPPS

Fills boxes twelve hours a day in a Southend factory. Collects vintage
motorcycles. Paints in a small council flat when money for materials permits.

29.6.54	Born Rochford, Essex.
1965-69	Eastwood High School, Southend. Failed every exam and left age fifteen.
1969-94	Worked as furrier, squadee in Parachute Regiment, in shoe factory, in electronics factory, lamp factory, switch gear factory, furniture factory, cartoonist for *Beano* and *Dandy*, then unemployed for two years.
1994-99	South East Essex College FE, then London Guildhall University BA (Fine Art).
2001-	Founded Southend Stuckists, exhibited in *Vote Stuckist*, Fridge Gallery, Brixton and subsequent shows. Staunch participant in Stuckist Turner Prize demonstrations.
2002	Son, Vinson (meaning son of Vincent), born 26 October.

He has lived in Leigh-on-Sea all his life – "the light on
the Thames estuary is incredible – it easily surpasses the
light of France." Used to circuit-race Aermacchi-Harley
Davidson and Yamaha motorcycles in Brands Hatch.
Stopped after 130 m.p.h. crash. Landscape painting
bought by critic Brian Sewell who wrote "Yours are
typically heterosexual studies, all surface and infusion
and slight stirrings in the loins." Pincham-Phipps
commented, "that's me – he got it bang on! I can't thank
him enough for his friendly advice and time over the last
few years." Figure study bought by Martin Clunes.

Selbstbildnis: "I'm in the painting in different guises.
Doing the painting gave me a quiet strength during a
time when I was feeling oppressed in a college
dominated by conceptual art. I thought, 'You bastards –
I'm not going to let you get away with it.' I just felt anger
at so much poor art being produced and promoted. My
tutor hated the painting because I was producing
figurative art."

"The gift of art was always there, but good teachers bring
it out to enable you to explore it and yourself. I do studies
all the time, even just sitting in a train station – sketch
books, bits of paper, anything. I change things during a
painting all the time. I'm not afraid of destroying a good
painting in the process of exploration."

SELBSTBILDNIS *1999 oil on canvas 175.2 x 115.5cm*

STEVEN COOTS

A recluse in Tunbridge Wells, dedicated to writing, music and staging 'Flash Mob' events.

SIR NICHOLAS SEROTA
2000
watercolour and gouache
on paper
c.28.4 x 19.6cm

29.9.1962	Born Stratford, London.
1973-79	West Hatch Technical High School, Chigwell, Essex.
1979-81	Havering Technical College Foundation Art.
1982-85	Maidstone Art College, BA (Fine Art – Film and Video).
1984	Met The Medway Poets, booked for a reading at college by fellow student Tracey Emin. Subsequently co-organised Maidstone Poets events with Charles Thomson.
1985-2000	Landscape gardener, dustman (one day), door to door double glazing salesman (half a day – led resignation of five man sales team), operating theatre technician, prison education art teacher, Marks and Spencer warehouse, university teacher.
1999	Exhibited in Stuckist show *The Resignation of Sir Nicholas Serota*, Gallery 108.
2000-	Tunbridge Wells Adult Education Centre tutor and freelance writer/illustrator.

Strongly anti-globalisation. Finally in a harmonious relationship. Working on a novel trilogy about emotional breakdown. Plays Scrabble recreationally (high word score 210). Would like to live by the sea.

Sir Nicholas Serota: "He strikes me as a faceless bureaucrat, and I wanted to capture a threatening feel in the painting. It's not necessarily about him, but what he represents – 'art business'.

"I usually use designer gouache on 100 gsm cartridge paper. You get a good strength of colour. The image is drawn from several different photographs – I'm looking for the strongest features that represent personality."

JONATHAN COUDRILLE

Conceived in cottage called *Wy Worrie*. Age 18 sold a painting to the Bank of Nova Scotia and bought a Rolls Royce.

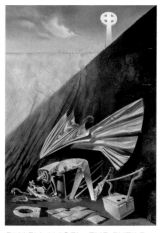

FALLEN ANGEL: THE FUTILE
DESCENT
oil on canvas
mid 90s
91.5 x 61cm

20.11.45	Born Landewednack, Cornwall.
1956-59	Boys public school (expelled).
1959-61	High Wycombe Art School (thrown out).
1961-63	Redruth Art School (provoked into leaving).
1963-68	Satirist BBC Radio 4 *Today*. Shot at on St Ives cliff.
1968-72	Experimental musician. Musical director Southern TV. Shot at on Cornish moors.
1972	Shunted by 30 ton truck on Holloway Road – bedridden 18 months.
1974-89	*Melody Maker* top rock/folk soloist. Bit parts on Dr Who. Musician, toured with Kazatka Cossack dance company. Shot at by Cambodian insurgents.
2001	Honorary Member, The Arts Club.

Hobby: cooking. Lost first wife to cancer, second to an Internet date. Now happily companioned. Permanent show: San Carlo, Highgate.

Fallen Angel: the Futile Descent: "From Lautreamont's 'the chance encounter of a sewing machine and an umbrella on a dissecting table' I don't see any great difference between the here and now world and the world in the mind."

"I use Renaissance techniques – imprimatura (a translucent wash) over charcoal drawing, lifting highlights with rag, intensifying tones with underpainting, overpainting colour with transparent glaze coats, intensifying lights in impasto."
Web site: www.jxc.ukf.net

MICHELLE ENGLAND

Michelle England lives in Brixton and part-times in a Chartered Surveyor's office in SW1.

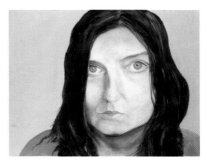

SELF PORTRAIT
2002
oil on canvas
40.8 x 51cm

19.12.69	Born Balham, London.
1981-87	Rowena High School for Girls, Sittingbourne, where as a fourteen-year-old she first encountered Bill Lewis and Charles Thomson as visiting poets (Lewis was put off school visits for life).
1987-1995	Clerk in Midland Banks, Kent.
1997-99	City Literary Institute, London. Foundation in Art and Design.
1999-2002	Camberwell College of Art and Design. BA (Hons) Fine Art (Painting).
2000	Joined Students for Stuckism.
2001	Founded Brixton Stuckists with Lara Brooks (now Francis).
2001	Exchange student at Facultdad de Bellas Artes, Madrid.

In residence with actor boyfriend. Has lived on a boat, sky-dived from 10,000 feet, climbed mountains and trampled through rainforests. Currently scouring thrift shops and watching trashy TV.

"I did *Self Portrait* during a period of great anxiety when I couldn't access my feelings. The painting is about the search for those feelings – looking at myself looking for myself."

"After quite a detour at art-college, I'm now exploring painting techniques which weren't covered there, and the tradition of portraiture."

JOHN HOSKING

Lives below a Martello Tower in Folkestone, never sunbathes on the beach, likes snooker.

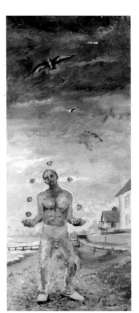

8.7.52	Born Epsom, Surrey.
1963-68	Therfield Comprehensive School, Leatherhead, Surrey.
1968-71	Motorbike accident (hit by a car), almost lost left leg, in hospital 18 months, then odd jobs – garage forecourt, nursery, bookshop, dockhand, repaired Teasmades and TVs.
1971-75	Epsom School of Art and Design, Foundation and DipAD (Diploma in Art and Design).
1975-76	Mopping blood up in Epsom Hospital, sold bric-a-brac in Petticoat Lane.
1977-	Managed Kent Probation art workshops, art tutor Adult Education.
1996-99	MA (Fine Art) KIAD (Kent Institute of Art and Design) Canterbury.
2000	Founded The Folkestone Stuckists.

Family with two teenage children. Holidays in Montpellier. "I like life to be as simple as possible." Family allotment – "leeks, runner beans, sunflowers, rhubarb and strawberries." Collections include Imperial College London and the Government Art Collection.

Juggler 2: "A few years back I learnt to juggle, which I still do. I like the symbolism of juggling lots of things at the same time. The figure is based on a French circus juggler. The landscape is Folkestone."

"I maintain the discipline of drawing. I think it's necessary for working out design and composition without the distraction of colour. I do colour studies of the landscape at different times of the day to see how light works."

JUGGLER II
1999
oil on board
58.4 x 23.9cm

NAÏVE JOHN

"Control freak faggot" with fluorescent red Italjet 125cc Scooter, paints 11pm – 8am every day.

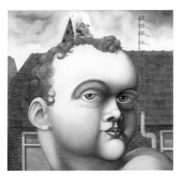

TOXTETH CHERUB
1997
oil on canvas
56 x 56cm

18.10.62	Born Poole, Dorset (moved to Glasgow age 2).
1973-79	Cumbernauld High School, Glasgow.
1979-83	Youth Training Scheme – played cards. Smoked dope daily, took LSD weekly.
1983	Greys School of Art, Aberdeen – accepted as exceptional student, then expelled.
1983-1998	Clinical depression, hospitalised for suicide attempt, postman, ceramicist, illegal alcohol salesman.
1998	Fled to Liverpool after homophobic knife attack.
1998-	Intensive psychotherapy.
2003-	John Moores University, Liverpool, BA (Hons) Art History course.
2004	Founded the Liverpool Stuckists.

As a child shared toilet with four families (no bath or hot water) in Glasgow tenement. Dr Who and Kraftwerk fan. Vegetarian. Shaven head. Arm tattoo of fish blowing bubbles. Collections include Hunterian Museum.

Toxteth Cherub: "This cherub has had his wings clipped because of the difficulty of making moral choices when there's so much shit happening in his environment, which is Toxteth."

"I used water-based oil paint and work in layers with every kind of technique you can imagine – rub with my fingers, wipe off with kitchen towel. I buy brushes from 'pound' shops. I do loads of studies. A painting takes six weeks." Web site: www.naivejohn.com

RACHEL JORDAN

Left London in 2001. Now shares a studio with Wolf Howard in an old sail loft by the River Medway.

THE WHOLE WORLD MINUS THE TURNER PRIZE EQUALS A BETTER WORLD
2001
acrylic on canvas
81.3 x 101.5cm

8.5.68	Born Maldon, Essex.
1979-86	The Gilberd School, Colchester.
1986-90	The University of Sheffield, BA (Dual Hons, French and Hispanic Studies).
1990-99	Monotonous office jobs.
1995-8	The City Literary Institute, London, Fine Art. Final show *The Princess Project*, paintings about Princess Diana.
2000-	Freelance picture researcher for BBC Books.
2000-	In Stuckist show *The Resignation of Sir Nicholas Serota* and subsequently. Member of North Kent Stuckists.
2003	Running children's art workshops in Medway galleries and schools.

95% recovered from ME. Still suffers from poverty. Likes cutting things (like hair and comments). Once camped on a Peruvian mountainside.

"I was there in my Pierrot clown outfit in the first Stuckist demonstration against the Turner Prize. I felt incensed by Martin Creed's light going on and off in Tate Britain, but was unable to do a satirical painting of it because there was nothing there, so I did this one instead."

"I start with an idea, research from photos and the internet, a location visit, compositional sketches and colour drafts – colour expresses the overall mood. I combine a graphic style with glazing."

JANE KELLY

Works as a journalist on a national newspaper in London and paints passionately the rest of the time.

7.5.56	Born Charlton, London.
1972-74	Pendeford High School, Wolverhampton.
1974-78	Stirling University, BA (Hons in History and Fine Art).
1978-79	Taught in Sosnowiec University, Poland.
1979-	Journalist *Walsall Observer, Times, Telegraph, Daily Mail, Express, Guardian*.
1995	Advanced Diploma in Painting, Central School, London.
2000	Stuckist guest artist. Exhibited RA Summer Show.
2003	Founded The Acton Stuckists.

Lives with cat Stanley and wild beehive in West London. Member of the Groucho, Cats Protection and Bat Conservation League. Reads books about the Holocaust. Holidays on the Wirral.

"I've always been fascinated by Myra Hindley's disastrous life and because her's was the first horrible crime I knew about as a child. I wanted to see what she might have looked like in the kind of family situation she was always denied."

"I'm trying to improve my skills all the time technically. I do a lot of life drawing and painting."

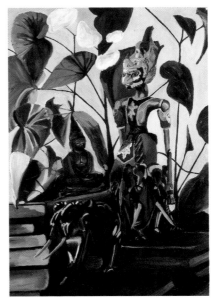

IF WE COULD UNDO PSYCHOSIS 2
oil on canvas
2000
60.8 x 50.6cm

EMILY MANN

Lives in Primrose Hill, DJ's for Glamourama, model, architectural student, dark, silent type.

10.2.83	Born Streatham, London.
1988-2001	Streatham Hill and Clapham High School.
2001-	The Barlett School of Architecture UCL, BSc (Architecture) course.
2003-	Model with Oxygen agency (fashion).
2003	Model for a Larry Dunstan photo with genetically erased nipples.
2003	Photographic model for Paul Harvey's *The Stuckist Punk Victorian*.
2004	Model.

On the Atkins diet – "You'd call me one of those continual hippies aware of food and the body". In Bikram yoga class. Enjoys market towns. Father is an osteopath and astrologer. "I was brought up to have a spiritual understanding." Has an Amazon Green pet parrot. Extreme sensitivity to "everything".

Somebody Called it Kali: "I wanted to show religious and iconic figures within religious and iconic setups, namely the triangulation of the canvas, as is found with the Madonna and Child."

"I use cartridge paper sized with rabbit skin glue. I paint with oils and sable brushes. I set up still life compositions, and do studies in different positions and lighting for two months before I do the painting."

SOMEBODY CALLED IT KALI
oil on paper
2000
c.79.8 x 54.9cm

REMY NOE

A Goth who lives doggedly in Maidstone, Kent, repairs Citroens and paints local ancient sites.

8.12.74	Born Bromley, Kent.
1986-93	Vinters Boys School – "that school was a living hell", Chatham Grammar.
1993-95	KIAD (Kent Institute of Art and Design), Canterbury, Foundation Art.
1995-97	KIAD, Canterbury, part-time BA (Fine Art), forced to leave by DSS.
1997-98	Resumed part-time BA, expelled for condemning "conceptual shit" and threatened with arrest.
1998-	Working in father's garage 'Medway Citroen' (01634 849609 repairs and spares).
2001-	Founded The Maidstone Stuckists. Exhibited in *Vote Stuckist* show and subsequently. Staged fourteen Maidstone Stuckist shows in pubs, libraries, fairs and Kent Music School, as well frequent Maidstone Stuckist expeditions for "painting, inspiration and getting drunk".

MARTIN I *2004 oil on canvas 28 x 57.5cm*

Hates cities. Explores Kent ancient sites – "Coldrum Long Barrow is as old as the pyramids". Researches Anglo-Saxon mythology. Goes to London Gothic nightclubs, "because there's nothing going on in Maidstone".

Martin 1: "The life model we hired disappeared to Eastbourne, so we got my friend's boyfriend to put on her dress and bra stuffed with socks. The group often hires models. We develop our skills and teach new members about painting."

"I visit the places – hidden sites, Goth bands – and draw or paint on the spot – between thirty minutes and three hours."

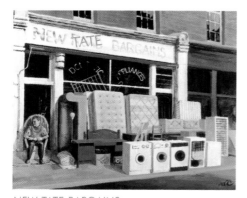

NEW TATE BARGAINS
oil on canvas on board
2001
45.5 x 55.7cm

MATTHEW ROBINSON

Qualified architect, movie junkie, drives an open-top silver Peugeot 206.

11.5.53	Born Folkestone, Kent.
1965-71	St Lawrence College, Ramsgate.
1971-72	Travelled in Greece. Lived in Dahlia Kibbutz, Israel.
1972-79	The University of Sheffield, BA, Diploma (Architecture), RIBA.
1979-1999	Architect – office blocks, shopping centres, hotel in Istanbul, housing in Germany, design manager for Daily Express building.
1997-2002	Camberwell College of Art, Foundation Art, BA (Fine Art, Painting).
2000	Member of Students for Stuckism, exhibited in *The Resignation of Sir Nicholas Serota*, participant in clown anti-Turner Prize demo, Tate Britain.
2002-	Part-time architect, painting, writing.

Loves the sea and the South of France, favourite film: Jean de *Florette/Manon des Sources*, ambition: "to find a woman who loves me", complaint: "not enough time to paint."

New Tate Bargains: "I did this in the Turner Prize year of Tracey Emin's bed, which I don't believe is art – it's emotionally unengaging stuff. Check the junk shop for the exhibits. It's based on a shop in Camberwell New Road, 'New Road Bargains'."

"At the moment I'm teaching myself the oil techniques that would traditionally have been taught in art schools, though I want to use them in a modern way."

GODFREY BLOW

Godfrey Blow lives in Kalamunda, Western Australia and supply-teaches as little as possible.

6.10.48	Born North Hykeham, Lincolnshire, England.
1960-66	Jordanthorpe Secondary Modern for boys, Sheffield.
1967-71	Sheffield Hallam University, BA Hons (Fine Art.)
1973-74	Manchester Metropolitan University, PGCE.
1974-82	Art Teacher, Priestmead Middle School, Kenton, London.
1976	Held first solo show at Barnet Arts Centre, London.
1982	Moved to Western Australia.
2002	Founded the Perth Stuckists.

Petrified of heights ever since his daughter nearly fell off a cliff (and told him, "I can always come back as a ghost"). Sinus and asthma problems. Shoe size 15. Drives a Mazda. Read *Lord of the Rings* four times.

Survivor: "I completed this painting shortly after losing both my parents. They both died within the space of three months. I was trying to come to terms with my personal loss by painting a tree which has several limbs hacked off, yet is still there against all the odds."

"I enjoy working on a painting over several months building up the surface in many layers." Web site www.kalamundaweb.com.au/godfreyblow/

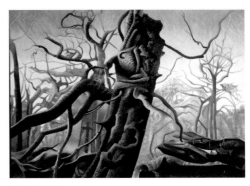

SURVIVOR
2001
oil on canvas on board
40.2 x 53.5cm

JESSE TODD DOCKERY

Lives in Lexington, Kentucky with Jessi Ann Fehrenbach and cats in a redneck neighbourhood.

5.2.76	Born in Gray Hawk, rural eastern Kentucky, USA.
1990-1994	Jackson County High School, Berea Community High School. Published art magazine "Abortion Stories" with later fellow Kentucky Stuckist, Edward Hieronymus.
1994-2002	University of Kentucky, never graduated. Drank excessively as a reaction to psoriatic arthritis and contemporary culture. Worked in a pornography store, bookshop, greenhouse, insurance office and Toyota factory. Delivered pizzas, washed dishes, edited radio programming guide.
2001	Co-founded The Mid Kentucky Stuckists with Jeffrey Scott Holland, exhibited with the Stuckists Travelling Show in USA.
2003	Quit drinking.

FRED'S GOT THE CREEPS AGAIN
2000
ink on canvas
c.36 x 64cm

2 CDs and US tours with bands *The Smacks!* and *Miss Kitty Twister & Her Hot Dogs*. Published Sexton Ming poems. Cult film enthusiast. Collects pulp fiction. Not quitting smoking.

Fred's Got the Creeps Again: "I don't remember much about the creation of this piece. I illustrate a balance between what is seen and what is felt. I draw it close to the vest.

"I alternate between Rapidograph technical pens and a dip pen with metal nibs in India ink on heavy Bristol paper. Drawings can be quick sketches or obsessively detailed."
Web site www.4dw.net/jtdoc

THE PEA SHOOTER GAME
2001
acrylic on canvas
c.34.5 x 44.5cm

BRETT HAMIL

Lives in Seattle, USA, picture framer by day, picture maker at night.

10.7.1975	Born Richmond, Virginia.
1989-93	Deltona High School, Deltona, Florida.
1993	Started painting after woodland visions and hypnagogic dreams.
1993-97	Flagler College, St. Augustine, Florida BA (Philosophy/Religion).
1997-99	Woodshop foreman in the Blue Ridge Mountains, dockhand, screen printer, architectural salvage hand.
2000	Moved to Seattle. Founded the Seattle Stuckists with Z.F. Lively and Jeremy Puma. Demo against Pigs on Parade art.
2000-04	Exhibited in Stuckists International Travelling Show USA, Orlando and Stuckism International Centre, London.

Tenor sax in art-rock band *The Feral Kid*. Publishes the art/satire 'zine *Whole New Drag*. Writes stories. Collects found photographs, wire twisties, bits of rusted metal and animal bones. Naps most afternoons.

The Pea-shooter Game: "One of the many open-air beer bars on the northeast coast of Florida. I feel right at home sipping pitchers of watery domestic in these 'locals only' bare-cinderblock dives, hidden far from tourists and interstate highways."

"Paintings are executed over a period of months, using a single small brush for the entire canvas." Web site: www.snant.com

HOLY COW
2001
acrylic on canvas
59.7 x 49.5cm

TONY 'BALONEY' JULIANO

Lives in Orange, Connecticut with pet, Commander Hamster, and paints in boxer shorts.

7.2.75	Born in New Haven, raised in Orange, Connecticut, USA.
1990-93	Amity High School, Woodbridge, Connecticut (Orange Arts Scholarship).
1993-98	Paier College of Art, Hamden, Connecticut: BFA (Illustration).
1997-	Quit gas station job and became full-time artist.
2001	Started Limited Liability Company, Agoo Art.
2001-	Founded the Connecticut Stuckists. Exhibitor/collaborator, Stuckism International Centre USA.
2003	Bailiff in Stuckist Clown Trial of President Bush anti-war demo, New Haven Federal Courthouse.

Collects comic books and toys – favourite is, "a depressing doll called 'Little Miss No Name' made by Hasbro". Moonlights as an art teacher. Avid photographer.

Holy Cow: "I've always tried to stay away from religion and doing religious comical artwork. But it's hard to escape from it. It's so easy to pick on them. While I kinda think like a cartoonist not a painter, I do consider myself a fine artist. My goal is to get people to laugh and if at times they get offended then so be it."

"My paintings are acrylic on stretched canvas with a pine frame that becomes an integral component of the piece. I use whatever supplies are on sale."
Web site www.agooart.com

Z.F. LIVELY

Currently planning an escape from Florida, "a very boring and tedious place."

1.10.71	Born Richmond, Virginia, USA.
1989-1994	Flagler College, St. Augustine, Florida: BA in Drama, Communications and English.
1994-1998	"Wasted time trying to figure out what to with my degrees."
1999	Moved to Seattle, WA. Internet retailing. Co-Founded Puppets Lounge Art Collective with Brett Hamil and Jeremy Puma, then –
2000-	Co-founded the Seattle Stuckists with them. Demo against Pigs on Parade art. Exhibited in Stuckists International Travelling Show USA and Stuckism International Centre, London.
2002	Left Seattle for St Augustine and various wage-slave jobs.

Zachary Forbes Lively. Multi-instrumentalist for rock band the *Wobbly Toms*. Encyclopaedic knowledge of entertainment trivia. Former radio DJ. Celebrates Christmas in July. Collects melted candle wax.

The Jesus Dummy Had Well Built Teeth: "This actually started out as an attempt to do a more "realistic" portrayal of the man. However, my Jesus looked more like a ventriloquist's dummy. I suppose one could stir up a bucket load of controversy but that wasn't my intent."

"I paint primarily from imagination, often building up background textures using a variety of materials such as candle wax, goauche, acrylic, and even coffee stains."

THE JESUS DUMMY HAD
WELL BUILT TEETH
2001
acrylic on canvas
35.5 x 27.8cm

TERRY MARKS

Lives on twenty-first floor in Chelsea, Manhattan, apprentice tattooist.

1.5.60	Born in the Bronx, NYC.
1976	City-As-School Alternative High School. Hitch-hiked, sold live lobsters, diner cook.
1980-89	Moved to London. Bartender ICA, Xmas postlady.
1981-87	Central St. Martin's – Foundation Art, BA (Hons) Fine Art Printmaking. Morley College. Goldsmith's College.
1987-89	Sales assistant Royal Academy.
1989-93	Returned to NYC. NY University. Left, infuriated by non-training (lecturer's slide show of his own jizz). NY Academy of Art (training included perspective and dissected cadavers) – MFA Painting.
2001	Founded New York Stuckists. Visited by Charles Thomson, given *The Stuckists* book torn up by Stella Vine.
9/11	Watched in shock from living room window the Twin Towers collapse.
2002-	Exhibited with Stuckists, England, Australia, USA.

Paints to cheesy 1960s French pop and Spaghetti Western soundtracks. Dreams of tropical islands. Likes crispy bacon and chipolatas. No TV.

Nightmare Mirror: "My pictures are wordless stories to be completed by each viewer."

"I arrange pictures I've collected in odd juxtapositions to trigger subconscious imagery and evoke a dream state. My compositions emerge from this process and the act of painting – lead white on a dark surface, then layers of translucent colours."
Web site www.artgalny.com

NIGHTMARE MIRROR
2001
acrylic on canvas
61 x 45.7cm

JESSE RICHARDS

Lives in New Haven, Connecticut, USA with non-psychotic girlfriend. Teenage ambition: forest ranger.

NIGHT LIFE
2002
oil on canvas
61 x 45.5cm

17.7.75	Born New Haven, Connecticut.
1990-94	Lyman Hall High School, Wallingord, Cooperative Arts High School, New Haven.
1994-96	Studied Film Production, School of Visual Arts NY. Quit after nervous breakdown.
1996-2000	Made punk films (destroyed in plumbing disaster). Directed *Hamlet* and *Look Back In Anger*. Arrested for reckless burning, destruction of property and disorderly conduct. Charges dropped. Began painting.
2001-02	Co-founded The New Haven Stuckists and Stuckism International Center USA with show *We Only Want to Do Some Fucking Paintings*.
2003	Co-organised The Clown Trial of President Bush anti-war demo, New Haven Federal Courthouse.
2004	Co-founded Remodernist Film and Photography.

Working with punk filmmaker Harris Smith. Visits Van Gogh's *Night Cafe* and Kirchner's *Girl in a Chemise*, Yale Art Gallery, every Sunday. Appeared nude wrapped in cellophane in SVA film.

Night Life: "This came out of heavy drinking and loneliness. New Haven's social scene is entirely going to bars, so it was my only way to meet new people."

"I have no training as a painter. I mix my paint on the canvas. I paint extremely fast to try and not lose the moment." Web site www.cuntyscoundrel.com

MARY VON STOCKHAUSEN

Lives in a castle built by her great-grandfather near Hanover, Germany. Studied art in Maidstone.

PREMONITION OF CRETE
2000
acrylic on board
99.1 x 74.3cm

25.05.74	Born in Göttingen, Germany.
1985-92	Steiner Schools Schloß Hamborn and Göttingen.
1993-95	Forestry training.
1995-96	Maidstone College of Art: Foundation Art.
1996-99	Edinburgh College of Art, BA (Hons) Glass and Architectural Glass.
2000	Founded The Lewenhagen Stuckists.
2001	Curatorial assistant *Vote Stuckist* show, Fridge Gallery, Brixton. Visited Seattle Stuckists USA. Anti-Turner Prize clown demo, Tate Britain.
2002	Participant in Stuckists Death of Conceptual Art demo outside White Cube gallery, Hoxton, London.
2003	Opens Stuckism International Centre Germany with residential studio and gallery.

Growing a maze as an open-air gallery for Stuckist paintings and sculptures. Manages family forestry business. Glass mural for the Steiner School, Hamborn.

Premonition of Crete: "I did this in June 2000, drawing the shapes from the unconscious. Six weeks later I went on holiday to Crete after being told to do so in a dream. The whole atmosphere – the colours, the sea, the city – was just like the painting."

"I start with the lines. I am exploring how line can change the atmosphere of a painting completely, and how it influences the use of colour."

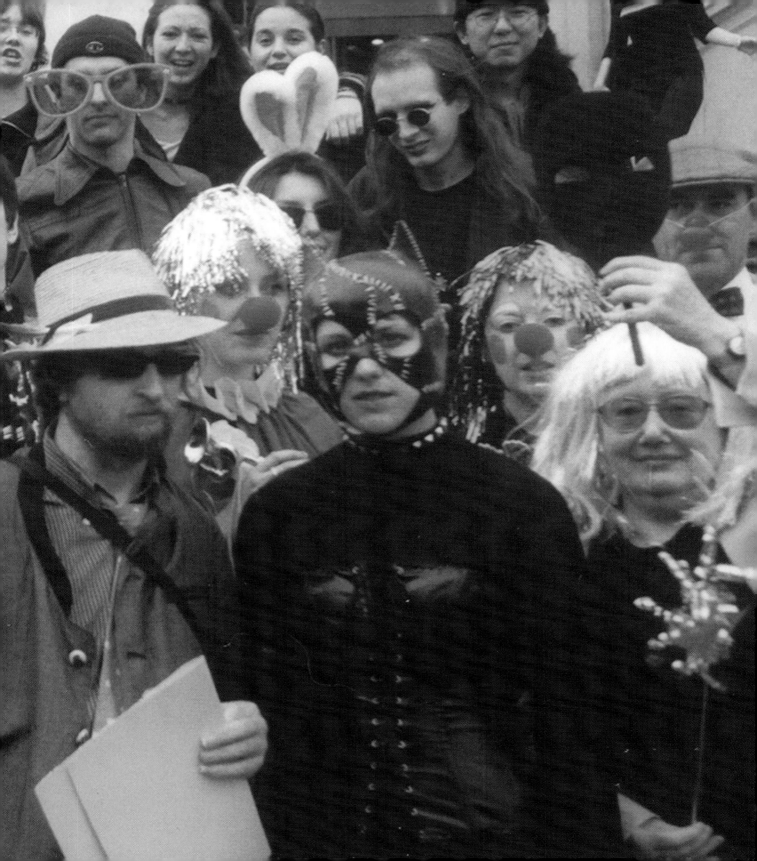

THE STUCKIST MANIFESTO

"Your paintings are stuck,
you are stuck!
Stuck! Stuck! Stuck!"
Tracey Emin

Against conceptualism, hedonism and the cult of the ego-artist.

1. **Stuckism is the quest for authenticity.** By removing the mask of cleverness and admitting where we are, the Stuckist allows him/herself uncensored expression.

2. **Painting is the medium of self-discovery.** It engages the person fully with a process of action, emotion, thought and vision, revealing all of these with intimate and unforgiving breadth and detail.

3. **Stuckism proposes a model of art which is holistic.** It is a meeting of the conscious and unconscious, thought and emotion, spiritual and material, private and public. Modernism is a school of fragmentation — one aspect of art is isolated and exaggerated to the detriment of the whole. This is a fundamental distortion of the human experience and perpetrates an egocentric lie.

4. **Artists who don't paint aren't artists.**

5. **Art that has to be in a gallery to be art isn't art.**

6. **The Stuckist paints pictures because painting pictures is what matters.**

7. **The Stuckist is not mesmerised by the glittering prizes,** but is wholeheartedly engaged in the process of painting. Success to the Stuckist is to get out of bed in the morning and paint.

8. **It is the Stuckist's duty to explore his/her neurosis and innocence through the making of paintings and displaying them in public,** thereby enriching society by giving shared form to individual experience and an individual form to shared experience.

9. **The Stuckist is not a career artist but rather an amateur** (amare, Latin, to love) who takes risks on the canvas rather than hiding behind ready-made objects (e.g. a dead sheep). The amateur, far from being second to the professional, is at the forefront of experimentation, unencumbered by the need to be seen as infallible. Leaps of human endeavour are made by the intrepid individual, because he/she does not have to protect their status. Unlike the professional, the Stuckist is not afraid to fail.

10. **Painting is mysterious.** It creates worlds within worlds, giving access to the unseen psychological realities that we inhabit. The results are radically different from the materials employed. An existing object (e.g. a dead sheep) blocks access to the inner world and can only remain part of the physical world it inhabits, be it moorland or gallery. Ready-made art is a polemic of materialism.

11. **Post Modernism, in its adolescent attempt to ape the clever and witty in modern art, has shown itself to be lost in a cul-de-sac of idiocy.** What was once a searching and provocative process (as Dadaism) has given way to trite cleverness for commercial exploitation. The Stuckist calls for an art that is alive with all aspects of human experience; dares to communicate its ideas in primeval pigment; and possibly experiences itself as not at all clever!

12. **Against the jingoism of Brit Art and the ego-artist.** Stuckism is an international non-movement.

13. **Stuckism is anti 'ism'.** Stuckism doesn't become an 'ism' because Stuckism is not Stuckism, it is stuck!

14. **Brit Art, in being sponsored by Saatchi, main stream conservatism and the Labour government, makes a mockery of its claim to be subversive or avant-garde.**

15. **The ego-artist's constant striving for public recognition results in a constant fear of failure.** The Stuckist risks failure wilfully and mindfully by daring to transmute his/her ideas through the realms of painting. Whereas the ego-artist's fear of failure inevitably brings about an underlying self-loathing, the failures that the Stuckist encounters engage him/her in a deepening process which leads to the understanding of the futility of all striving. The Stuckist doesn't strive — which is to avoid who and where you are — the Stuckist engages with the moment.

16. **The Stuckist gives up the laborious task of playing games of novelty, shock and gimmick.** The Stuckist neither looks backwards nor forwards but is engaged with the study of the human condition. The Stuckists champion process over cleverness, realism over abstraction, content over void, humour over wittiness and painting over smugness.

17. **If it is the conceptualist's wish to always be clever, then it is the Stuckist's duty to always be wrong.**

18. **The Stuckist is opposed to the sterility of the white wall gallery system** and calls for exhibitions to be held in homes and musty museums, with access to sofas, tables, chairs and cups of tea. The surroundings in which art is experienced (rather than viewed) should not be artificial and vacuous.

19. Crimes of education: instead of promoting the advancement of personal expression through appropriate art processes and thereby enriching society, the art school system has become a slick bureaucracy, whose primary motivation is financial. The Stuckists call for an open policy of admission to all art schools based on the individual's work regardless of his/her academic record, or so-called lack of it.

We further call for the policy of entrapping rich and untalented students from at home and abroad to be halted forthwith.

We also demand that all college buildings be available for adult education and recreational use of the indigenous population of the respective catchment area. If a school or college is unable to offer benefits to the community it is guesting in, then it has no right to be tolerated.

20. Stuckism embraces all that it denounces. We only denounce that which stops at the starting point — Stuckism starts at the stopping point!

Billy Childish and Charles Thomson 4.8.99

The following have been proposed to the Bureau of Inquiry for possible inclusion as Honorary Stuckists: Katsushika Hokusai, Utagawa Hiroshige, Vincent van Gogh, Edvard Munch, Karl Schmidt-Rotluff, Max Beckman, Kurt Schwitters.

REMODERNISM

'towards a new spirituality in art'

Through the course of the twentieth century, Modernism has progressively lost its way, until finally toppling into the bottomless pit of Post Modern balderdash. At this appropriate time, The Stuckists, the first Remodernist Art Group, announce the birth of Remodernism.

1 The Remodernist takes the original principles of Modernism and reapplies them, highlighting vision as opposed to formalism.

2 Remodernism is inclusive rather than exclusive and welcomes artists who endeavour to know themselves and find themselves through art processes that strive to connect and include rather than alienate and exclude. Remodernism upholds the spiritual vision of the founding fathers of Modernism and respects that bravery and integrity in facing the travails of the human soul through a new art that was no longer subservient to a religious or political dogma and which sought to give voice to the gamut of the human psyche.

3 Remodernism discards and replaces Post Modernism because of its failures to answer or address any important issues of being a human being.

4 Remodernism embodies a spiritual depth and meaning and brings to an end an age of scientific materialism, nihilism and spiritual bankruptcy.

5 **We don't need more dull, boring, brainless destruction of convention, what we need is not new, but perennial.** We need an art that integrates body and soul and recognises the enduring and underlying principles which have sustained wisdom and insight throughout humanity's history. This is the proper function of tradition.

6 **Modernism has never fulfilled its potential.** It is futile to be 'post' something which has not even 'been' properly something in the first place. Remodernism is the rebirth of spiritual art.

7 **Spirituality is the journey of the soul on earth.** Its first principle is a declaration of intent to face the truth. Trust is what it is, regardless of what we want it to be. Being a spiritual artist means addressing unflinchingly our projections, good and bad, the attractive and the grotesque, our strengths as well as our delusions, in order to know ourselves and thereby our true relationship with others and our connection to the divine.

8 **Spiritual art is not about fairyland.** It is about taking hold of the rough texture of life. It is about addressing the shadow and making friends with wild dogs. Spirituality is the awareness that everything in life is for a higher purpose.

9 **Spiritual art is not religion.** Spirituality is humanity's quest to understand itself and finds its symbology through the clarity and integrity of its artists.

10 **The making of true art is man's desire to communicate with himself, his fellows and his God.** Art that fails to address these issues is not art.

11 **It should be noted that technique is dictated by, and only necessary to the extent to which it is commensurate with the vision of the artist.**

12 The Remodernist's job is to bring back God into art but not as God was before. Remodernism is not a religion, but we uphold that it is essential to regain enthusiasm (from the Greek *en theos*, to be possessed by God).

13 A true art is the visible manifestation, evidence and facilitator of the soul's journey. Spiritual art does not mean the painting of Madonnas or Buddhas. Spiritual art is the painting of things that touch the soul of the artist. Spiritual art does not often look very spiritual; it looks like everything else because spirituality includes everything.

14 Why do we need a new spirituality in art? Because connecting in a meaningful way is what makes people happy. Being understood and understanding each other makes life enjoyable and worth living.

SUMMARY

It is quite clear to anyone of an uncluttered mental disposition that what is now put forward, quite seriously, as art by the ruling elite, is proof that a seemingly rational development of a body of ideas has gone seriously awry. The principles on which Modernism was based are sound, but the conclusions that have been reached from it are preposterous.

We address this lack of meaning, so that a coherent art can be achieved and this imbalance readdressed.

Let there be no doubt, there will be a spiritual renaissance in art because there is nowhere else for art to go. Stuckism's mandate is to initiate that spiritual renaissance now.

Billy Childish and Charles Thomson 1.3.00

THE STUCKIST PHOTOGRAPHERS

Stuckist photographers share many of the ideas that unite Stuckist painters. They have their own website and a manifesto, written in December 2003 by Larry Dunstan and Andy Bullock, that highlights their commitment to the pursuit of integrity and expressionism as a right. They aspire to a new spirituality in art.

ANDY BULLOCK (CO-FOUNDER)
The photography of language and the language of photography is central to his work. *I Will Always Love You* balances on the boundaries of visual and verbal language, making an elegiac play on the word "always" as both suggestive of the eternality of death and the end of worldly affection.

LARRY DUNSTAN (CO-FOUNDER)
His photographs explore our perceptions of the anatomy as an object of beauty, an object of curiosity, and an object of voyeurism. He uses prosthetics and computer retouching. The 'abnormalities' of these forms address our obsession with perfection and body image. The seductive scarlet lips in *Distortions: Untitled 1, 2004* metamorphose into a scar, an open wound, a rose petal. "… I had never thought of my photos as dark, they were just the ideas in my head … I feel the world is both dark and light, weird and normal, I am just showing that part of the world."

WOLF HOWARD
"There is something special about a pin-hole camera. There is a beauty in its simplicity and rawness that technology has not been able to better." Wolf Howard's subjects are personal and local and include Chatham Bandstand, Rochester Castle and Cathedral, friends like Billy Childish, or personal belongings like a typewriter, a pocket watch or a trench cap. The poetry of the mundane is what he seeks.

CHARLES THOMSON
I photograph people and situations that occur around me naturally and spontaneously. We're always acting out underlying emotional and psychological issues unconsciously in our daily life. Sometimes it's possible to capture an image where this becomes more apparent — it works on both mundane and symbolic levels. A photo is always locked into a particular time and place, which reduces its universality, whilst increasing its documentary value. I was previously hampered by 35mm film — in the two years since I acquired a digital camera, I have taken around 5,000 photos.

Original text supplied by Agnieszka Studzinska.

I WILL ALWAYS LOVE YOU
Andy Bullock
Photographic print
110 x 110.5cm

DISTORTIONS:
UNTITLED 1, 2004
Larry Dunstan
Photographic print
23.5 x 30.5cm

BILLY AND WOLF
Wolf Howard
Pinhole photograph
23 x 23cm

MOTHER AND FATHER
Charles Thomson
Digital photograph

FOOTNOTE FROM A CO-FOUNDER

WHY DO THE STUCKIST PHOTOGRAPHERS EXIST? We exist because Larry Dunstan was the first person to ask, "Is there a place for photography in Stuckism?" That was the question that started it all for us; and because I asked the same question, independently, shortly afterwards, the idea for the Stuckist Photographers was born. Our manifesto was the culmination of much thought and self-questioning by the two of us, after being introduced to each other by Charles Thomson sometime in mid 2003. We are a wholly independent group which believes in the fundamental tenets of the Stuckist and Remodernist ideals and our interpretations of these principles manifest themselves in photography and (more recently) film rather than painting. Charles Thomson was invited to join us and show his photography under the same terms as any other member and has no directorial role in the running of the group.

We exist to express ourselves through our work and to continually push the boundaries of our chosen medium.

Andy Bullock London, August 2004